IMAGES
of America

TUSCALOOSA

IMAGES
of America

TUSCALOOSA

Amalia K. Amaki
and Katherine R. Richter

ARCADIA
PUBLISHING

Published by Arcadia Publishing
Charleston, South Carolina

Printed in the United States of America

Library of Congress Control Number: 2011924717

For all general information, please contact Arcadia Publishing:
Telephone 843-853-2070
Fax 843-853-0044
E-mail sales@arcadiapublishing.com
For customer service and orders:
Toll-Free 1-888-313-2665

Visit us on the Internet at www.arcadiapublishing.com

To the people of Tuscaloosa

CONTENTS

ACKNOWLEDGMENTS

The authors are grateful to many people who were instrumental in making this book possible. We thank the staff at the W.S. Hoole Special Collections Library at the University of Alabama, especially Marina Klarić; the Tuscaloosa County Preservation Society, especially the 2010–2011 Board of Directors; The Birmingham Civil Rights Institute, especially Lawrence J. Pijeaux Jr.; The Paul R. Jones Archives; Ian Crawford; Chere Flanagan and the church office of First Methodist Church; Bill Pool; David Nelson; Charles Hilburn; Tommy and Helen Stevenson; Robert Mellown; Diana Lindsey Hewlett; Donna Cox Baker and Meredith Purser; Carolyn Bolden and Emma Jean Melton of the Murphy African-American Museum; Deborah P. Crockett; Teresa Larson; Memnon Tierce II; Jessica Lacher-Feldman; Mary E. Peek; Moundville Archaeological Park; Betty Slowe; Robert Sutton; Anthony Bratina; the *Birmingham News*; and the countless individuals who have worked tirelessly over the years to build up the files and records of the Tuscaloosa County Preservation Society. We have enjoyed delving into the rich history of the town that one author has always held dear as her home (Richter), and the other has come to see with new eyes as a result of this project.

Unless otherwise noted, images are courtesy of the W.S. Hoole Special Collections Library, University of Alabama.

Helpful research sources included:

Hubbs, G. Ward. *Tuscaloosa: Portrait of an Alabama County*. Northridge, CA: Windsor Publications, Inc., 1987.

Library of Congress Historic American Buildings Survey, online.

Library of Congress Prints and Photographs Archive, online.

Encyclopedia of Alabama, online.

Hughes, McDonald. *A History and Personal Account of Secondary Education for Blacks in the Tuscaloosa City School System, 1889–1976*. Self-published, 1979.

Sellers, James Benson. *History of the University of Alabama, Volume I: 1818–1902*. Tuscaloosa, AL: University of Alabama Press, 1953.

Tuscaloosa News.

Tuskaloosa Sesquicentennial Souvenir Program, 1819–1969.

Wolfe, Suzanne Rau. *The University of Alabama: A Pictorial History*. Tuscaloosa, AL: University of Alabama Press, 1983.

INTRODUCTION

On April 27, 2011, Tuscaloosa, Alabama, experienced one of the most destructive and deadly tornadoes in its history. On June 19, in the midst of vigorous clean-up and relief efforts, the US Conference of Mayors voted Tuscaloosa one of the "most livable" cities in America—it was tied with Tallahassee, Florida. Balancing such polar realities is somewhat customary in the history of the city. Cultural conflict, natural disaster, economic downturn, war, and racial harshness have shaped Tuscaloosa's past as has its capacity to recoup, rebuild, and redefine itself socially, culturally, politically, and economically. From an immediate association with Crimson Tide football to affiliations with fried catfish and Dreamland barbeque, and from historic structures and homes defining downtown and characteristic neighborhoods to ongoing struggles with race relations, Tuscaloosa is in many ways quintessentially Southern while simultaneously confirming its own distinct personality.

The city's name echoes its historical inseparability from the Black Warrior River, the Native American chief whose fateful encounter with Spanish explorer Hernando de Soto in 1540 was a prelude to white settlement in the area, and the Choctaw language that placed an indelible stamp on its cultural legacy. This southernmost site on the fall line of the river became familiar territory to various native people who sought land and commerce opportunities in west Alabama. The "Black Warrior Village" dated from the 1500s, with periodic decades of vacancy. Choctaw and Creek were the predominant Native American inhabitants, with a large Creek band established in the village by around 1800. The gradual encroachment of whites was apparent after the War of 1812 as log cabins began to appear along the river. When a slightly injured Gen. Andrew Jackson ordered Gen. John Coffee to lead an attack on the village in 1813, during the Creek War, the battle ended with the troops burning the village in retaliation for the kidnapping of Martha Crawley at Duck River, Tennessee. This left few Creek in the area. Those who remained were relocated west of the Coosa River in east Alabama. The majority of the Choctaw living near the Creek village relocated to just west of present-day Tuscaloosa. By 1836, President Jackson had ordered the removal of all native people to Indian Territory in the relocation known as the "Trail of Tears."

In early 1816, the Thomas York family was the first white family to permanently settle in the Black Warrior Village; by the end of that year, several others joined them. The settlers named the southwest location "Tuscaloosa," from the Choctaw words "tushka" (warrior) and "lusa" (black). Alabama became a territory in 1817, and on December 13, 1819, the town of Tuscaloosa was incorporated one day before Congress admitted Alabama to the Union as a state. Colin Finnell was commissioned to design the city in early 1821, with lots auctioned off in November of that year. From 1826 to 1846, Tuscaloosa was the state capital, replacing Cahaba. The board of the University of Alabama held its first meeting in 1822, with the Alabama state legislature taking action in 1827 confirming Tuscaloosa as the site for the institution and authorizing trustees to move forward with land purchases and approval of William Nichols as architect. When initial construction was completed, the doors to the university opened in April 1831 with 52 students.

These developments, along with the region's growing economy, increased the city's population to 4,250 by 1845. In the 1840s, a tornado destroyed most of the city's original structures, and a growing population in the eastern part of the state led legislators to move the capital to Montgomery, causing the number of inhabitants in Tuscaloosa to decrease to 1,950 by 1850. In the 1850s, the establishment of Bryce State Hospital for the Insane helped improve the financial situation in Tuscaloosa. Meanwhile, the university became a military university in 1860. The decision transformed the institution into a military training campus that ultimately served as an active enlistment source for the Confederate cause during the Civil War. On April 3, 1865, Brig. Gen. John T. Croxton led a Union army cavalry brigade (Croxton's Raiders) into the city and burned all but four of the university's buildings, the city's foundry, factories and warehouses, and 2,000 bales of cotton before burning the covered bridge used to enter Tuscaloosa—the critical access to Northport—as the Union army continued west.

Tuscaloosa seemed to transition relatively well after the war, but underlying social, political, and economic turmoil became evident with Alabama placed under federal occupation—for two months after the war there was no state government, and, in 1868, a new state constitution shifted voting opportunities from pro-Confederacy whites to black males. The process of reopening the University of Alabama became a point of contention for angry whites, fueled by the lack of leadership on campus, instability in city government, and the arrival of white supremacist Ryland Randolph in 1867. Randolph, the new owner and editor of the Tuscaloosa *Independent Monitor* and principal organizer of the Tuscaloosa County Ku Klux Klan, led the campaign against the new social and political order. When victory was proclaimed at the University of Alabama in 1871, it came in the form of a new president and new faculty who were more to Randolph's liking. A hard-fought election in 1874 that was won by conservative Democrats supported by Randolph further confirmed both his influence on the region and the fact that Tuscaloosa County had "returned to the politics of white supremacy."

Soon after the war, many African Americans in rural areas returned to the jobs they had performed as slaves, working on farms in much the same manner as before. Freedmen with skills started small businesses and worked as cooks, teamsters, and in building industries. African Americans established their own churches, such as the African Methodist Episcopal Zion Church of Tuscaloosa, with a vital component being Sunday school, aimed at raising the level of black education. White clergyman Rev. Charles A. Stillman facilitated the founding of Tuscaloosa Institute—a school for the "training of Negro ministers"—in 1876. Under his leadership, its academics expanded in 1893, and in 1895 it was renamed Stillman Institute. The school later became Stillman College, which evolved into a four-year liberal arts college and is now one of Alabama's historically black colleges and universities.

William Carlos Jemison was elected mayor in 1880 and led Tuscaloosa through an era of modernism that included forming a strong public school system, improving streets and infrastructure, and poising the city for industrial growth. The construction of a system of locks and dams on the Black Warrior River by the US Army Corps of Engineers in the 1890s opened up an inexpensive link to the gulf seaport of Mobile, stimulating the mining and metallurgical industries of the region. The introduction of football to the university in 1892 marked the beginning of a cultural tradition that would extend far beyond the campus, benefiting the city economically and socially. During the Depression, Tuscaloosa fared relatively well because of New Deal programs that stimulated education as well as the economy. Tuscaloosa's industries were invigorated by the US entry into World War II, providing employment opportunities for unemployed young adults and others and breathing new life into area farms.

The postwar years ushered in the civil rights era and Tuscaloosa experienced its share of headlines and turbulent events, often centered on the university. In the aftermath of the heightened social unrest, steady growth continued in Tuscaloosa and at the University of Alabama thanks to a strong national economy.

One

BLACK WARRIOR

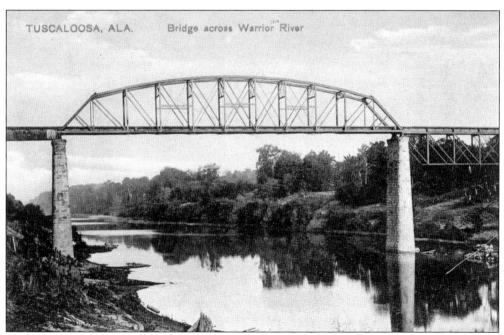

The story of "Tuskalusa" begins with the joint narrative of the Black Warrior River and the native people who formed the first community near its southern shores. The Black Warrior Village was established by 1580 and was home to many groups, primarily Choctaw and Creek. The destruction of Black Warrior Village in 1813 during the Creek War contributed to an increase in the permanent settlement of whites along the river.

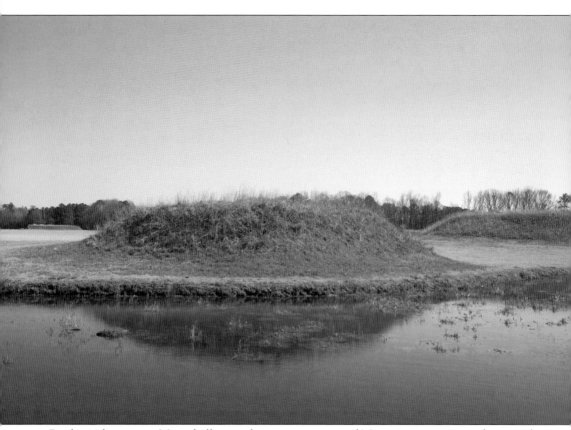

By the 11th century, Moundville was the greatest center of Mississippian native culture in the Southeast. Situated on a bluff overlooking the Black Warrior River and bordering present-day Tuscaloosa and Hale Counties, Moundville was a 300-acre village at its peak (between the 13th and 15th centuries), enclosed within a 10-foot wooden palisade and housing roughly 3,000 people. The group controlled a landmass that stretched 25 miles; including the extended community of related people dwelling along the external periphery of the wall, the total village population reached 10,000 people. Their earthworks included 29 mounds, with heights ranging from 3 to 60 feet, topped by temples, burial sites, council houses, and homes of nobility. They created characteristic pottery, basketry, and metalwork and had a highly sophisticated agricultural system that supported a profitable maize crop, among other products. These Mississippians enjoyed a strong economy and worked trade routes that extended along the southeastern coast of North America.

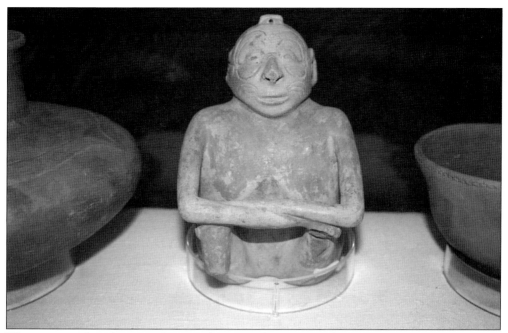

The strong craft tradition in the Tuscaloosa area has roots in the Mississippian pottery making from 800 to 1600. The Native Americans dug local clay, tempered it with additives to prevent shrinking and cracking during the drying and firing processes, and used slab-built construction and a "coiling" method to form smooth walls. Decorative incising, stamping, or shaped pieces were applied to the wet clay. After drying, the objects were fired.

Mississippian Indians customarily buried their dead with pottery, ceremonial items, and other objects associated with the deceased. Burial sites were located at designated mounds. Excavations at Moundville led by Walter Jones in the late 1930s uncovered these remains. Moundville Archaeological Park is under the direction of University of Alabama Museums, part of the University of Alabama.

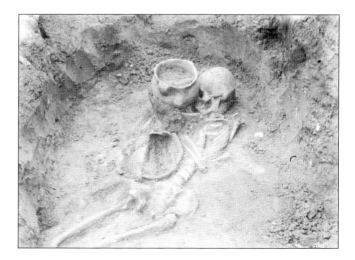

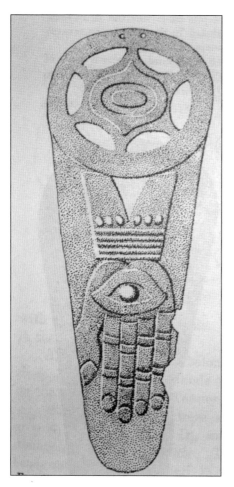

The eye in the hand represents a merging of iconography, ceremony, and mythology and is a common motif on various Mississippian objects, but especially rattlesnake disks and copper or shell gorgets, such as the one shown here. Often linked to deity, the open eye staring out from an open palm is also believed to symbolize a portal to another world.

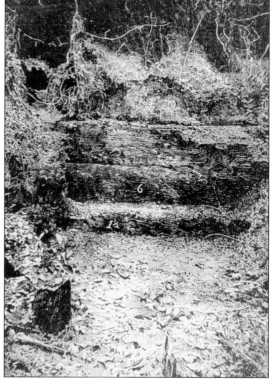

Amateur archeologist C.B. Moore's impressive illustrations of his pioneering work at Moundville in 1905 stimulated the interests of looters and vandals as well as scientists. When the site was secured through efforts of the Moundville Historical Society, Walter Jones, and the University of Alabama, meaningful projects were conducted, including excavation of this Mississippian house in July 1939.

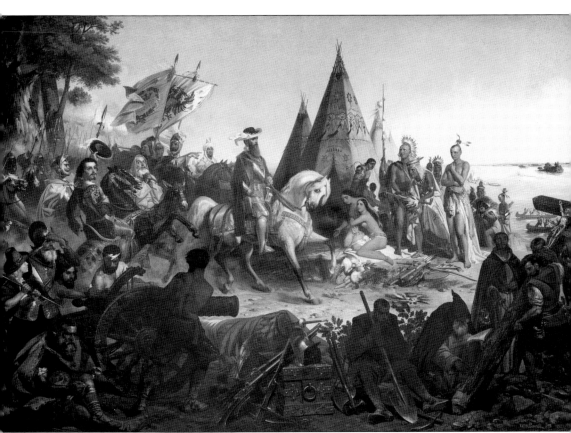

Chief Tuskaloosa (also Tuskalusa, Tastaluca, or Tuskaluza) was a paramount chief of a Mississippian ancestral group of native people, including Choctaw and Creek, in the present-day area of the state of Alabama. He was an imposing figure and powerful leader. Spanish explorer Hernando de Soto recorded, "[his] appearance was full of dignity. He was tall of person, muscular, lean, and symmetrical. He was the suzerain of many territories, and of numerous people, being equally feared by his vassals and the neighboring nations." Chief Tuskaloosa encountered de Soto when the Spaniard traveled through the territory in the fall of 1540. The chief was captured and held by de Soto as insurance for safe passage and to guarantee the collection of 100 women when they reached the province of Mabila, located southwest of present Tuscaloosa. After their arrival, Chief Tuscaloosa's men—aware he had been seized—launched a surprise attack on the expedition. While the fate of Chief Tuskaloosa is unknown, roughly 2,000 of his people were killed in battle and the village was burned.

Hernando de Soto's campaign to gather treasures from the New World for Spain were set back in Mabila. Although he won the battle against Chief Tuskaloosa's men, de Soto lost 22 conquistadors and 150 others who were severely injured from more than 700 arrow wounds. He also lost valuables, including a dozen horses (with up to 70 more injured) and freshwater pearls, in the Mabila fire. It took the expedition a month to become fit enough to travel.

After the failure of earlier attempts to find gold or silver, de Soto became concerned about the credibility of his exploration and continued across the Black Warrior River, near Moundville. A number of de Soto's men succumbed to disease in 1542, leaving only a fraction of the initial group to continue to Mexico a few years later. De Soto's venture had impact long after he departed, as many native lives were lost to the diseases, particularly smallpox, spread by the expedition. Also, despite the inability to locate any semblance of the once-powerful province of Tuscaloosa, Spanish mapmakers consistently included the location on maps, unaware that it no longer existed.

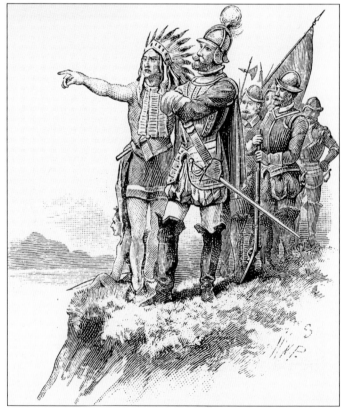

On September 24, 1813, Davy Crockett joined the Second Regiment of Tennessee Volunteer Mounted Riflemen and fought in the Creek War. He marched south into Alabama and took part in raids of Creek villages along the Black Warrior River. He became a scout, hunter, trapper, and woodsman, feeding starving troops with the game he caught.

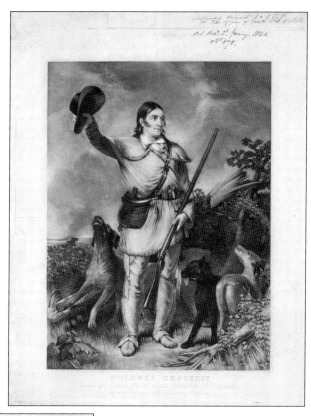

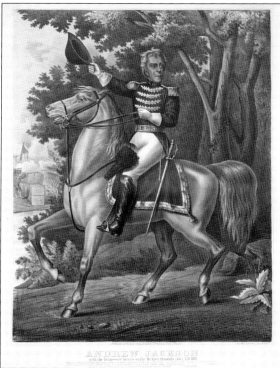

Gen. Andrew Jackson ordered Gen. John Coffee to attack the Black Warrior Village during the Creek War in 1813. The village was burned as retaliation for the kidnapping of Martha Crawley at Duck River, Tennessee, and the surviving Creeks were moved to eastern Alabama, west of the Coosa River. Most Choctaw relocated west of Tuscaloosa. President Jackson spurred the passage of the Indian Removal Act in 1830, resulting in the relocation of over 40,000 Native Americans living east of the Mississippi, some of whom were forced to travel on the Trail of Tears.

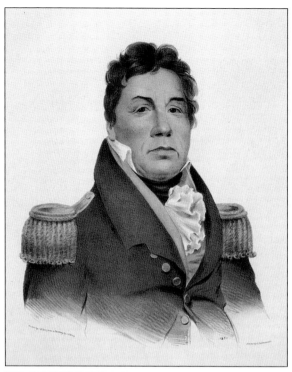

Chief Pushmataha was one of three Choctaw leaders (along with Puckshenubbee and Moshulitubbee) decorated by the American government. He fought with Gen. Andrew Jackson's forces in the Creek War and signed the Treaty of the Choctaw Trading House on October 24, 1816, selling land east of the Tombigbee River for $6,000 annually for 20 years and $10,000 in merchandise. This opened the Black Warrior Valley for settlement.

The 1860 map below indicates the degree to which states used slave labor and the slave population vis-à-vis that of whites, with an inset that outlines the products of the Southern states. Tuscaloosa is located at the center of the area designated as the cotton district, with a projected slave presence of 50 percent of the total population.

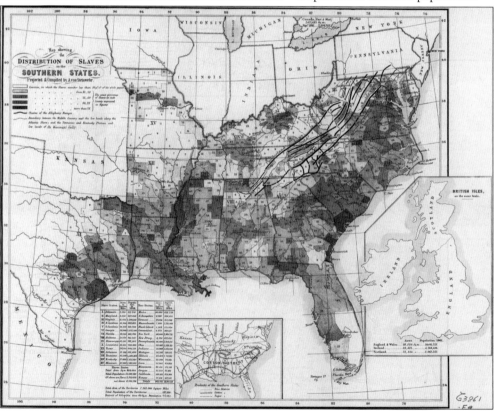

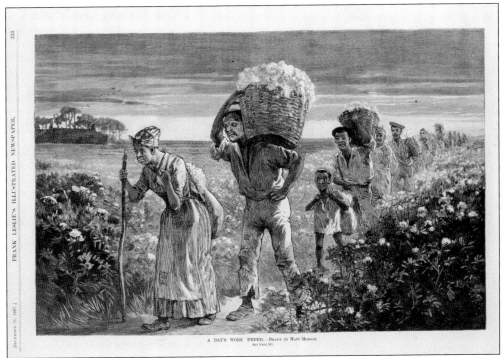

A DAY'S WORK ENDED.—Drawn by Matt Morgan.

The increasing white population and incorporation of the town of Tuscaloosa led to the enslavement of African people who provided free labor, as illustrated in this 1887 engraving by Matthew Morgan. The 1860 Tuscaloosa County census lists some of Tuscaloosa's most prominent families among the slaveholders, including Alfred Battle, Rufus Clement, James Dearing, Robert Jamison, Robert Jemison Jr., and John W. Pruett. (Courtesy of the Library of Congress, Prints and Photographs Division.)

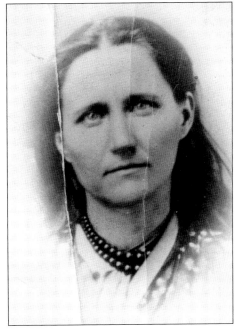

Martha Jane Tilley was born on December 22, 1845, just 10 years after the Cherokee signed the Treaty of New Echota, which resulted in their forced removal to the Oklahoma Indian Territory. According to family history, groups of Cherokees went "underground" to avoid removal. Tilley's parents were among those individuals. It is believed the family either assumed an Anglo name or gave the children to trusted settlers for safety. Tilley married Caleb King, a prominent landowner and postmaster of the Hobart Post Office in present-day Cullman County. They had five children, with four surviving into adulthood. Martha Jane Tilley King died on July 13, 1901, and is buried in New Hope Cemetery in Cullman County. Tuscaloosa native and author Katherine Richter is her great-great-granddaughter. (Courtesy of Sharon Richter and Katherine Richter.)

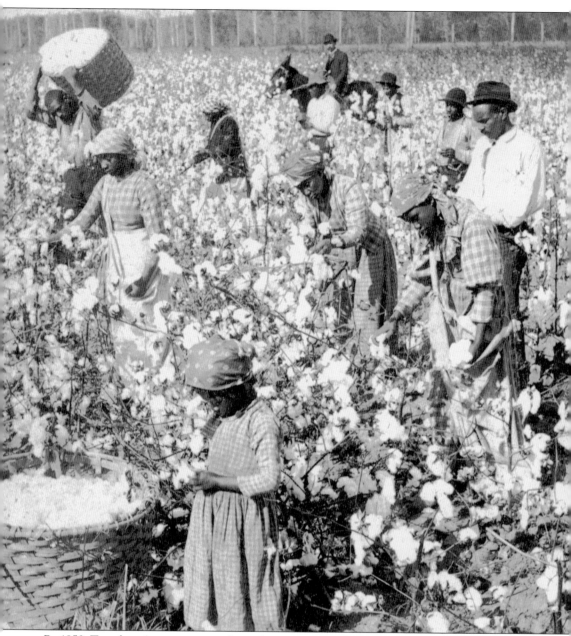

By 1850, Tuscaloosa's economy was dependent on cotton. Cotton was easy to grow, increased in value, and transported well by steamboat. Slaves were extensively used on cotton plantations as demand for the product continued to skyrocket along with market price increases. Slaves generally worked cotton fields from sunup to sundown. This photograph shows cotton-pickers on a farm in the Tuscaloosa area. (Courtesy of the Paul R. Jones Archives.)

The Black Warrior River is a poetic reminder of what Tuscaloosa was, is, and can be. A marker of the boundaries and routes of ancient native communities, its waters tumbled over great shoals in North Alabama before cascading to the fall line that is the heart of Tuscaloosa. After tempering the rocky, steamy terrain of the hilly Cumberland Plateau, the river continued its descent, gaining strength as it approached the fall line, then rippled through the rich, fertile soil of the state's Black Belt before rushing toward a dramatic release at the east bank of the Tombigbee River. The city, much like the river that runs through it, had a tumultuous birth, navigated the consequential trails carved out of its choices, and endured an assortment of wildernesses with gumption to move forward. Tuscaloosa's pioneers—who built log homes, developed farms, constructed schools, formed governments, established commerce, and formed social systems—were diverse in terms of origin, race, religious beliefs, politics, work, and taste, but were bound by a reliance on the Black Warrior River.

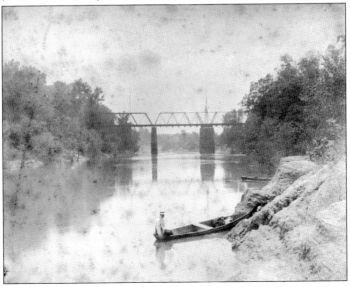

This c. 1900 photograph of a rural Tuscaloosa-area farm offers some sense of how remote and potentially isolated farmers could be. This was particularly the case when the work force was diminished during eventful points in history, such as the post-slave era, the era of African American migration and the "New Negro," the Depression, and periods of industrial growth.

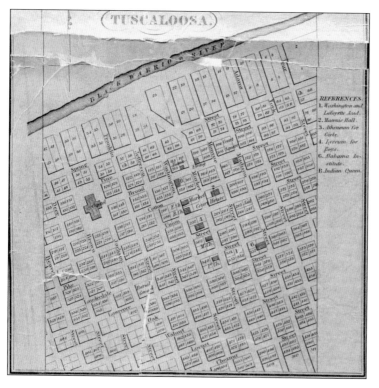

This surveyed grid of Tuscaloosa streets in 1837 references six important community structures: Washington and LaFayette Academy, Masonic Hall, Atheneum for Girls, Lyceum for Boys, Alabama Institute, and Indian Queen. (This survey is courtesy of John La Tourrette's *An Accurate Map of the State of Alabama and West Florida*.)

Two

CHURCH AND STATE

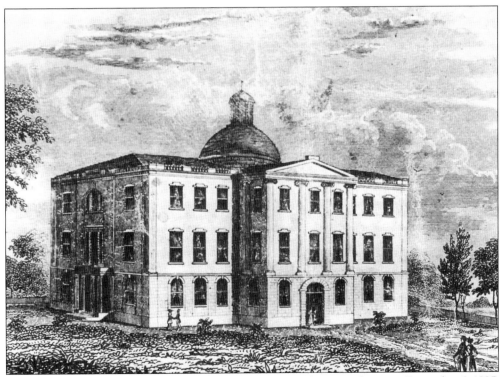

When the General Assembly of Alabama moved the capitol to Tuscaloosa on December 6, 1825, state architect William Nichols used the grid layout of the city to form ideas. He replaced the city's rugged, frontier image with that of prosperity and elegance, beginning with the capitol. Gov. Gabriel Holmes praised Nichols's work, referring to the capitol as "a symbol of civilization in Alabama" in a 1929 speech to the assembly.

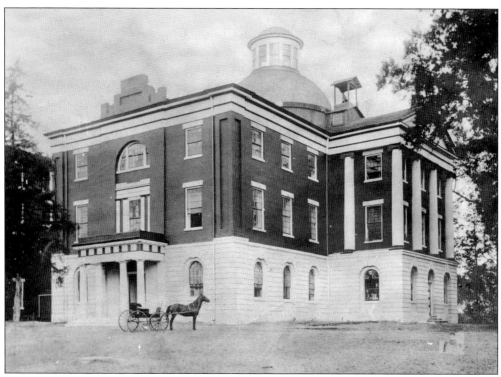

The Old State Capitol (1829–1846) was constructed on Childress Hill, a bluff above the Black Warrior River that offered optimum visibility of the copper dome from steamboats and throughout the city. The $100,000 capitol was in the shape of a Greek cross, with its dome above a 90-foot rotunda and the second and third floors supported by a rusticated stone basement. The main floor contained identical north and south pseudo-porticos with Doric columns, and an arched, gabled eastern entrance with Ionic columns opened to Broad Street (later University Boulevard). The sheathed copper on the dome, which was prone to leaking, was replaced with wood shingles long before the 1890 photograph above was taken. The concert hall in the interior chamber is pictured below.

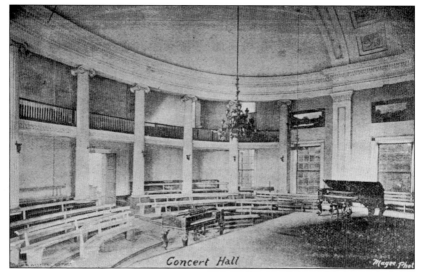

Concert Hall

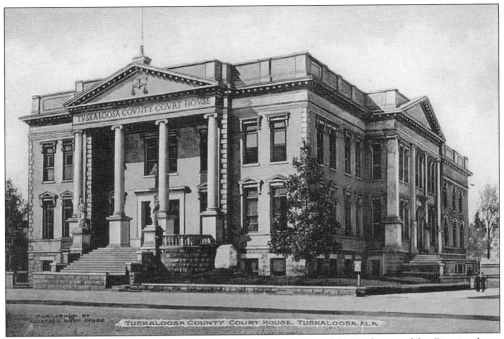

The heavily ornamented Tuscaloosa County Court House of 1907, designed by Birmingham architect William Earnest Spink, was razed to make way for this building. The 1950s courthouse pictured here was made of limestone and marble panels. The allegorical statues that stand on large, square, pink marble pedestals on either side of the front steps of the current county courthouse are all that remain of this courthouse building. Incidentally, the statues are all that remain from the 1907 courthouse building as well. (Courtesy of the Tuscaloosa County Preservation Society.)

In this c. 1915 photograph, an unspecified group poses outside the old post office. This former post office and federal courthouse was completed in 1910 under supervising architect James Knox Taylor and was used as the site for the US District Court for the northern district of Alabama. There is one female in the large gathering, and most of the men have tags on or near their left lapels.

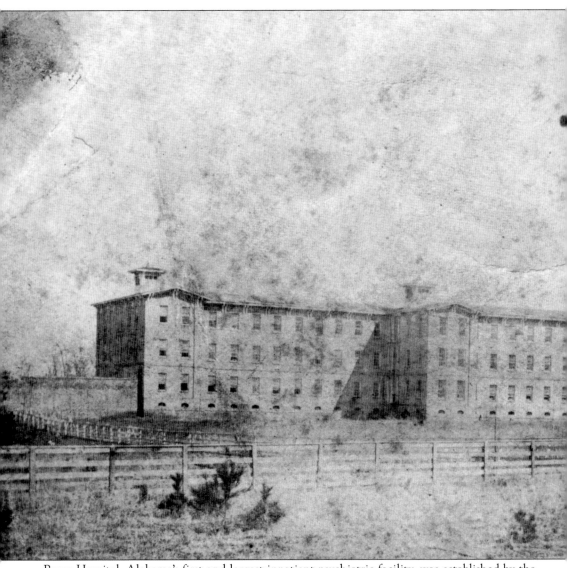

Bryce Hospital, Alabama's first and largest inpatient psychiatric facility, was established by the state legislature in 1852 as the Alabama Insane Hospital (AIH). Designed by Thomas Kirkbride on 326 acres adjacent to the university, it took almost a decade to build. The hospital opened in 1861 with 27-year-old psychiatric pioneer Peter Bryce as superintendent. Dr. Bryce championed humane treatment of and for the mentally ill and gained notoriety locally and nationally for his "moral treatment" therapeutic approach. He adopted a policy characterized by kind treatment, no

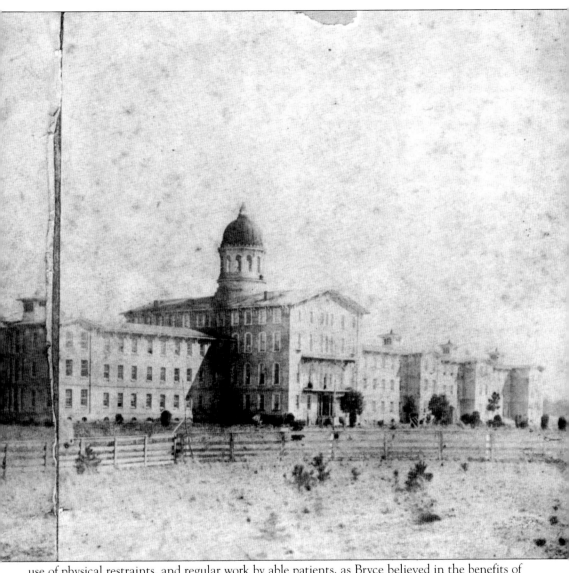

use of physical restraints, and regular work by able patients, as Bryce believed in the benefits of emulating normal environments and that idleness gave patients too much time to focus on their conditions. He also saw economic returns from patient labor as AIH faced diminishing state funds while patient populations grew; income from the hospital's vegetable garden and manufacture of household goods became a vital source of financial support. In 1865, the hospital served as a refuge for wives and children of university faculty when Union soldiers burned the campus.

In 1890, Bryce trustees built this home adjacent to the university cemetery for Assistant Steward Charles C. Kilgore. In 1901, the Kilgores began boarding students at their home, known as "Kilgore Ranch." Anna Hunter, the university's first female instructor, was the coed supervisor. In 1908, the residence housed Bryce employees. The University of Alabama acquired the property in 1976, and it served as the offices of *Alabama Heritage* upon the magazine's founding in 1986.

Fire Station No. 1, built by Judge Henry B. Foster in 1916, was originally located on Seventh Street between Twenty-third and Twenty-fourth Avenues. The fire department moved to a new location in 1922; due to the relocation and new, unfamiliar equipment, the fire department was unable to save the capitol building when it burned down in 1923. (Courtesy of the Tuscaloosa County Preservation Society.)

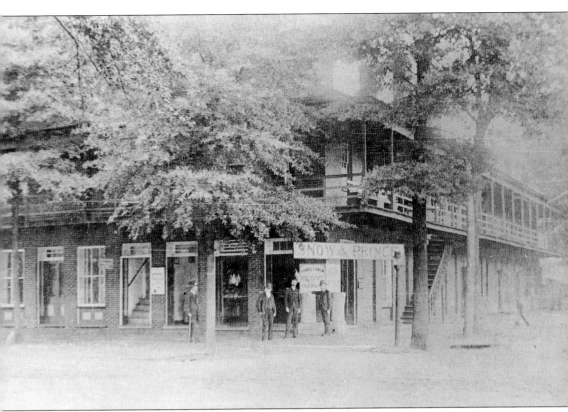

The State Bank, a brick building constructed in the Federal style, was erected in 1828, when Tuscaloosa was the state capital. The bank prospered in its first few years to the extent that the legislature abolished the state tax system and the entire cost of government was paid out of the bank's profits. The bank failed, however, due to political corruption and the panic of 1837. In the 1850s, the building was the residence of Albert Gooch and, later, James Harris Fitts. The structure was demolished in 1919. In the summer of 1987, an archaeological dig on the site, at the corner of Greensboro Avenue and University Boulevard, revealed the sandstone foundation and hundreds of artifacts ranging from buttons to glassware. (Courtesy of the Tuscaloosa County Preservation Society.)

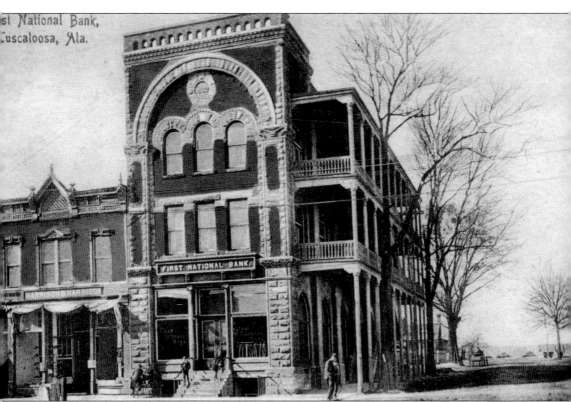

The First National Bank, founded in 1871, had an original building at 2210 Broad Street—until it burned in December 1872. Construction began in 1891 at the bank's second location, 2320 Broad Street (University Boulevard). At this new location (pictured here), the bank was located on the first floor, while the second and third floors were rented to attorneys and other businessmen. After the bank moved in 1930, the building became the site of Adrian's Department Store (1947–1981). The building is presently the home of DePalma's Italian Cafe and retains touches of its past inhabitants. The "Adrian's" name is still inlaid in the tile at the front door, and the medallion honoring the original 1871 founding of the bank is still visible above the third-floor windows. (Courtesy of the Tuscaloosa County Preservation Society.)

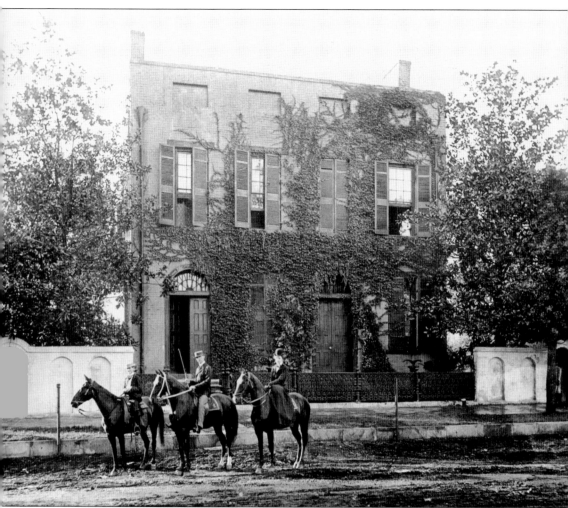

Pictured here on horseback are, from left to right, James Fitts Alston, Samuel Fitts Alston (second president of City National Bank), and Marilou Alston. The Fitts family was important to Tuscaloosa's commerce in the late 19th century. James Harris (J.H.) Fitts Jr. established the first private bank in Tuscaloosa, the Bank of J.H. Fitts and Company, in 1865. The bank was nationalized as City National Bank on April 1, 1902, with J.H. Fitts Jr. as president, William Faulcon Fitts as cashier, and R.H. Cochrane as assistant cashier. Its original board of directors included J.H. Fitts Jr., William Faulcon Fitts, Alston Fitts, William McGiffort, E.M. Elliott, and Samuel Fitts Alston. J.H. Fitts Jr. also served as city attorney, depositor for Confederate funds (from 1863 until the end of the Civil War), president of the Alabama Bar Association (in 1890), first president of the Alabama Banks Association, and treasurer of the University of Alabama from 1872 to 1912.

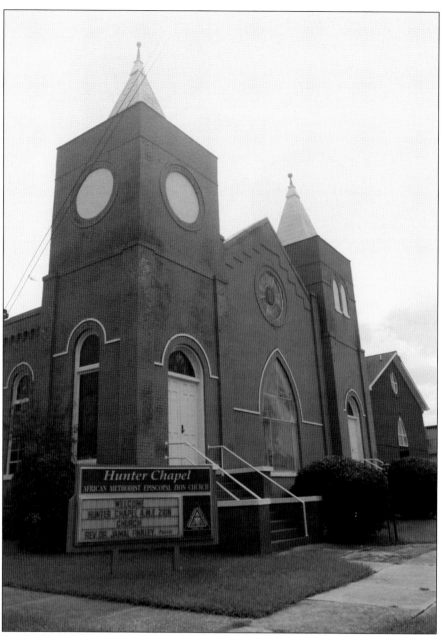

The Hunter Chapel African Methodist Episcopal (A.M.E.) Zion Church was organized in 1866 and was the first black Methodist church in Tuscaloosa. The congregation's first house of worship was a rented building located at the present-day site of Bryant-Denny Stadium. The church built the first structure in 1878 and erected the current structure at 1105 Twenty-second Avenue in 1881. The exterior brick was added in 1910 under the direction of noted African American architect Wallace A. Rayfield. During the Reconstruction days of the 1870s, the church included a school for the children of freed slaves. The church was named for Rev. E.H. Hunter, who served with distinction as pastor in the 1880s. Hunter Chapel A.M.E. Zion Church is listed on the Alabama Register of Landmarks and Heritage and continues to have a thriving congregation. (Courtesy of the *Tuscaloosa News*.)

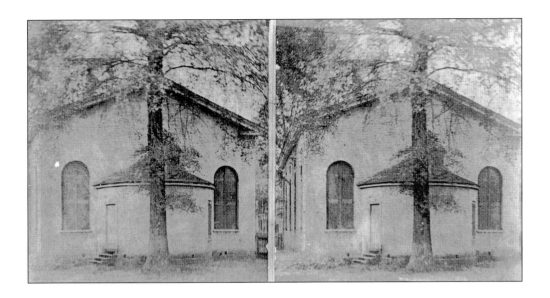

Christ Episcopal Church was organized on January 7, 1828, and is the second oldest Episcopal church in Alabama. The following month, architect William Nichols was asked to estimate the cost of constructing a new church building and was probably the architect of the original classic structure (above). On April 12, 1831, Rev. Alva Woods was installed in Christ Church as the first president of the University of Alabama. The church was enlarged and remodeled in 1882 in the Gothic Revival style (below). (Below, courtesy of the Tuscaloosa County Preservation Society.)

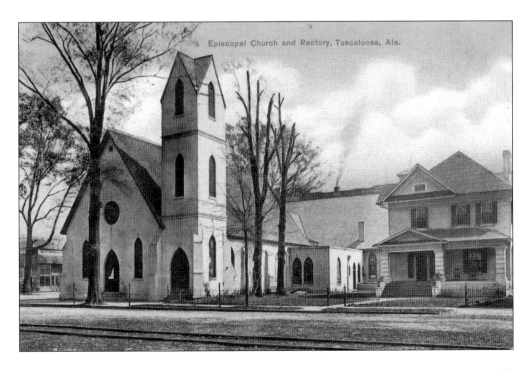

First Presbyterian Church was organized in 1820, with Rev. Andrew Brown serving as the first minister. On a cold January day in 1831, the church erected its first building on the same site where the sanctuary sits today. In 1876, during the pastorate of Dr. Charles Allen Stillman, the church founded Stillman College, a training school for black ministers. The present church structure was built in 1921; in 1952, it was remodeled and redecorated under the inspiration of local philanthropist Mildred Westervelt Warner. (Both courtesy of Diana Lindsey Hewlett.)

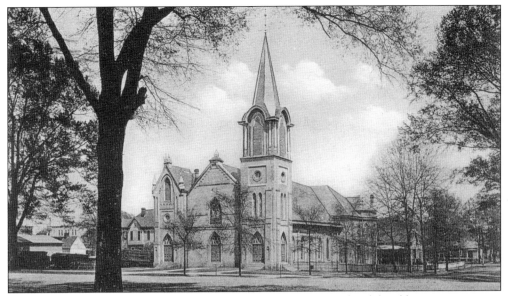

First Baptist Church of Tuscaloosa was organized in 1818 and is considered the oldest congregation in Tuscaloosa County. The antebellum church pulpit was often filled by University of Alabama presidents Alva Woods and Basil Manly, who both had seminary degrees and were ordained Baptist ministers. The Gothic church building (pictured) was erected in 1884 to the specifications of architect J.R. Ryan of Chattanooga, Tennessee. Its beautiful Victorian stained-glass memorial windows were removed in 1958, reinstalled, and incorporated into the current sanctuary, constructed on the same downtown corner at 721 Greensboro Avenue. (Courtesy of the Tuscaloosa County Preservation Society.)

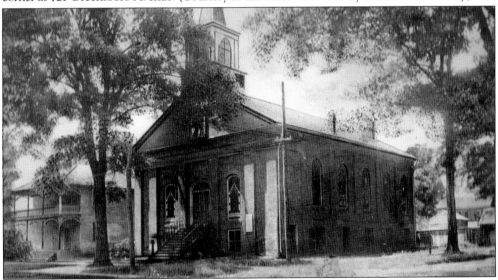

First United Methodist Church was organized in June 1818, with Rev. Ebenezer Hearn serving as the first minister. The first place of worship took four years to build and was completed in 1834. The present church was completed in 1913 and is to the side of the location of the early sanctuary. The church bell was created in 1828 by the famous coppersmith-silversmith Paul Revere and his sons in Boston and is the only Revere bell listed in Alabama. The Revere bell is still rung on Sunday to commence services and for weddings and funerals. (Courtesy of the First United Methodist Church, Tuscaloosa.)

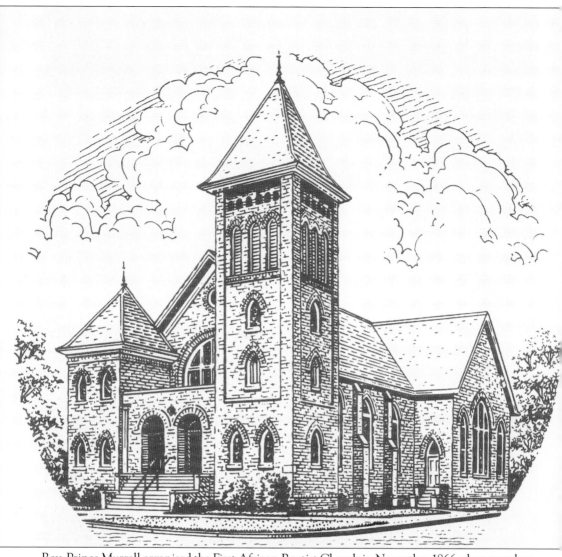

Rev. Prince Murrell organized the First African Baptist Church in November 1866 when members split from the First Baptist Church. Reverend Murrell served as pastor for 14 years. He became one of the founders of Selma University when the Alabama Colored State Convention held its sixth session in the church in January 1875 and adopted a resolution to establish a school to train ministerial students. The existing church building was constructed in 1907 and is a replica of the first chapel on the Tuskegee Institute campus, which was destroyed by fire. In 1963, Dr. Martin Luther King preached the installation sermon for Rev. T.Y. Rogers. The street adjacent to the church bears Reverend Rogers's name. The First African Baptist Church is listed in the National Register of Historic Places. (Courtesy of the Tuscaloosa County Preservation Society.)

The parish of St. John Catholic Church was established in 1844 after several visits from the diocese of Mobile. It was determined that the Catholic following was strong enough in Tuscaloosa to support a pastor, and a place of worship was provided. The first baptism occurred in February 1846. The original church building was 31 feet wide by 55 feet long when erected. In 1888–1889, the belfry was added, the stone steps were placed in front, and the stained glass windows and pews were installed. It is one of only two antebellum churches in Tuscaloosa. (Courtesy of Diana Lindsey Hewlett.)

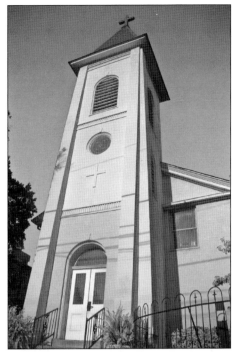

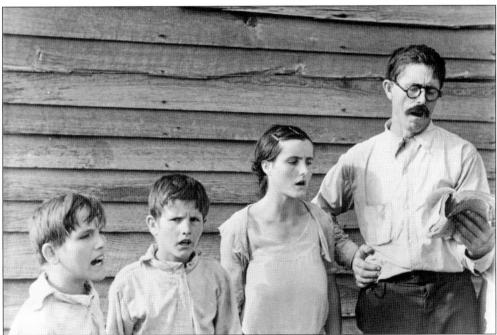

In this c. 1935 photograph taken by Walker Evans, sharecropper Frank Tengle and members of his family wear dress clothes and engage in Sunday singing, a rural Alabama tradition. It is one of several images of the Tengle family in the album that Evans completed for the US Resettlement Administration, "The House and Family of Frank Tengle near Moundville, Hale County, Ala." The picture is also included in the book *Let Us Now Praise Famous Men*, with text by James Agee and photographs by Evans. (Courtesy of the Library of Congress, Prints and Photographs Division.)

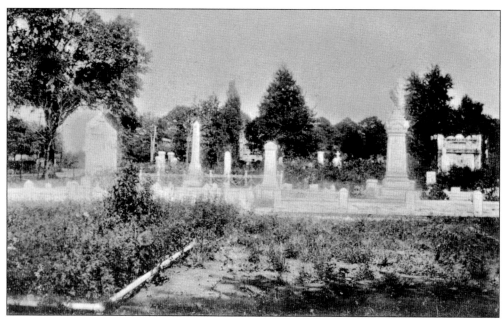

The image above is from a 1908 postcard of Greenwood Cemetery. The sign at the entrance to the cemetery states: "Laid out in the original city plan, Greenwood is Tuscaloosa's oldest surviving cemetery. It has been in continuous use since before 1820. The earliest marked grave is dated 1821. Some of the ornate marble markers were carved in New Orleans however, many were carved from local sandstone by masons working on the state capitol once located three blocks north. Only grass covers many of the older plots of African and Native Americans and white settlers. Greenwood is the final resting place of five veterans of the American Revolution, Confederate General Phillip Dale Roddy, Sallie Anne Swope, volunteer Civil War nurse, Jack and Jerry Winn who bought their freedom from slavery, Solomon Perteat, a prominent antebellum 'free man of color,' and more than 2,500 individuals in marked and unmarked graves."

Three

ROLLING WITH THE TIDE

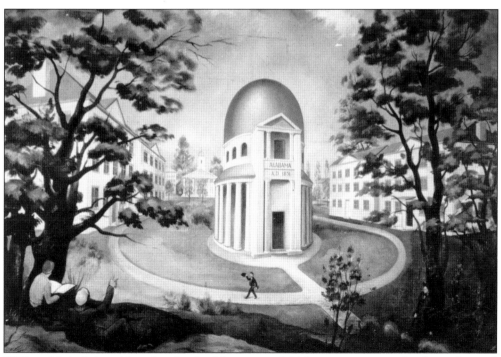

William Nichols based his plan for the University of Alabama campus on the design he used at the University of North Carolina at Chapel Hill, incorporating existing buildings with new construction. The university's rotunda may have been inspired by Thomas Jefferson's plan for the University of Virginia or Henry Holland's royal Marine Pavilion in Brighton, England.

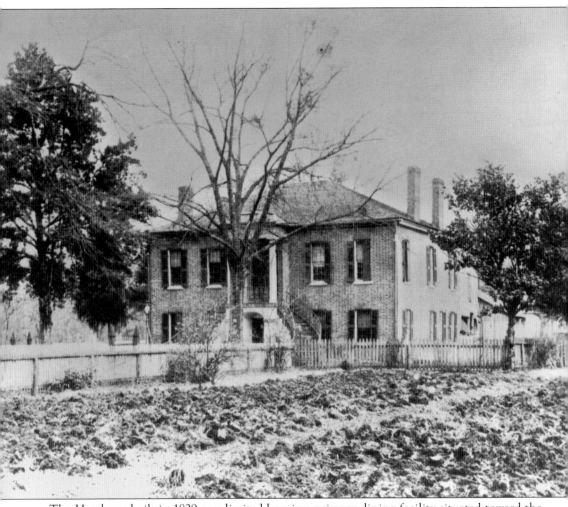

The Hotel was built in 1829 as a limited housing, primary dining facility situated toward the northwest corner of the campus. In 1848, its name changed to Steward's Hall when it converted to faculty residences. In 1865, the property became the residence of Prof. John Wood Pratt and wife Mary Grace Crab Pratt and was called Pratt House. When Josiah Gorgas left the presidency for health reasons in 1879, he moved his family into the residence, which has since been known as the Gorgas House. This 19th-century photograph shows the building's original porch from 1829, cast-iron railing from 1853, and exterior stairs added after 1847, when it was used as faculty housing.

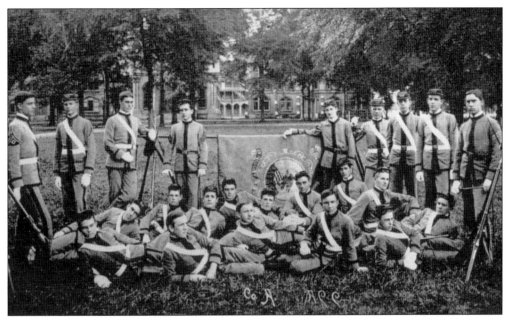

On February 23, 1860, the Alabama General Assembly authorized the creation of a military department at the university in response to increasingly unruly student behavior. Pres. Landon Cabell Garland, having lobbied successfully for the new order, placed all students under military discipline and assumed an additional role as superintendent of the Alabama Corps of Cadets. In this 1893 photograph, a cadet company poses on the campus lawn in front of Woods Hall.

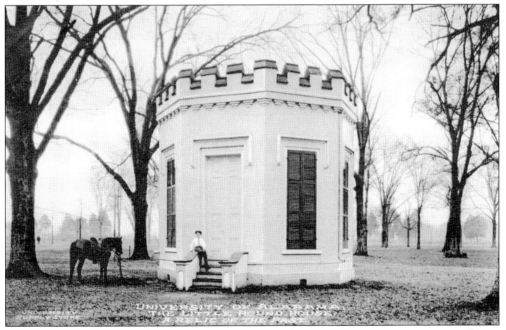

When the university established a strict system that transformed it into an army camp, a guardhouse was constructed in 1859 and 1860 as a weather shelter for sentinels on guard duty. President Garland considered guard duty beneficial to the mental and physical welfare of the corps, preventing cadets from slipping into behavior and situations detrimental to the "morals of the cadets."

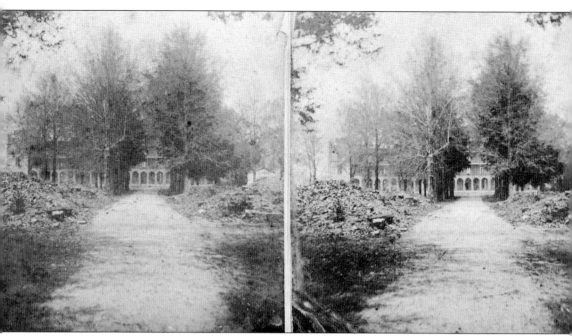

An 1874 stereopticon photograph of the campus shows distant views of the center walk extending towards the ruins of the Rotunda, which was completed in 1831 and burned by Union troops in 1865. The building that would later be named Woods Hall is visible behind the ruins at left. Although only a portion of the grand design was completed when Union troops destroyed the campus, there was sufficient structure to make the intended impression, with the Rotunda serving as an iconic feature. Amicus Veritates made his case in an extensive article in *The* (Huntsville) *Advocate* of October 9, 1830, when final touches were yet to be added: "The principal building . . . and one of the finest in the southern States is the Rotunda; this building is three stories in height, is circular as its name imports, is surmounted by a dome, and it has a colonnade of 24 columns surrounding it; it is divided into two compartments, one below and one above, the lower one is intended for a commencement hall, and the upper room for a library . . . it will add honor to its architect."

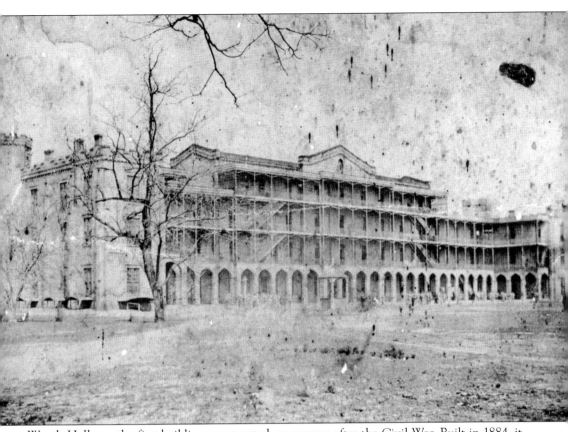

Woods Hall was the first building constructed on campus after the Civil War. Built in 1884, it was initially named Centre Building, and then the "barracks," because it served as housing for cadets. Built by former mathematics professor and architect James Thomas Murfee, who served as commandant of the Alabama Corps of Cadets during the Civil War, it housed men on the second and third floors in rooms that exited to the outside. Concerned about conduct and safety issues, Murfee believed the layout encouraged good study habits, minimized opportunities to slip into deviant behavior, and provided optimum security for cadets. His original architectural plan had Woods Hall on one side of an enclosed square, designed in such a way that the only access off the square could be locked during study hours. The building was eventually named for the university's first president, Alva Woods.

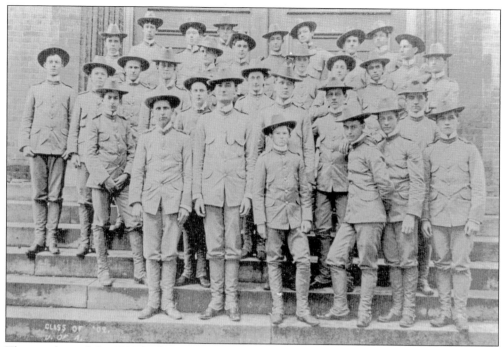

The members of the 1898 freshman class posed in uniforms similar to those worn by US troops during the Spanish American War. By the time these freshmen matriculated to senior status, the appropriateness and effectiveness of the military system at the university was being openly questioned and vigorously challenged by student leaders.

The laundry building, built around 1888 when the university was a military school, was part of the campus reconstruction after its destruction by Federal troops during the Civil War. It had modern equipment to care for cadet uniforms, including a special press used to iron collars. It was located at the top of Marr's Pond. Water came from Marr's Spring, which ran underneath; pumps drew water into the laundry from the spring.

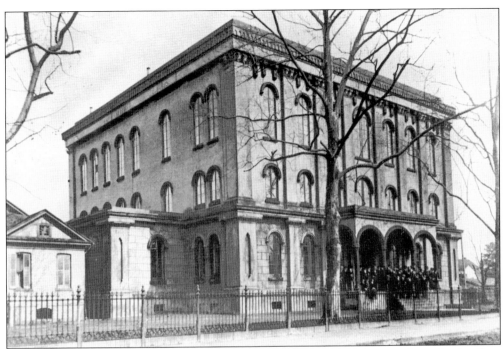

The original plans for the University of Alabama included the establishment of a medical college on the site currently occupied by the President's Mansion. The state legislature incorporated the college as a department of the University of the State of Alabama in 1860, but it was built in Mobile instead with a separate budget and board of trustees.

The President's Mansion, pictured here in the 1890s, was one of four buildings that survived campus attacks by Federal troops during the Civil War. As Pres. Landon Garland and cadets fled, his wife, Louisa Frances Garland, took refuge with her family at Bryce Hospital. Upon learning that the campus was being burned, she returned to the mansion and convinced Union soldiers torching the house to both spare her home and help servants extinguish the fire.

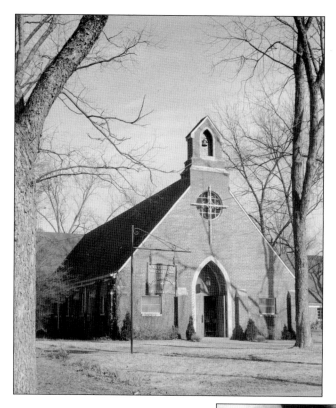

The Canterbury Episcopal Chapel and Student Center for the University of Alabama is located in the heart of its campus, near the quad. It was once located in a house on Thomas Street, when Rev. George Murray was chaplain. The chaplaincy became a parish in 1951, which led to the construction of the current chapel and student center. It is somewhat unusual, being both a chaplaincy and a parish.

The Medical College of Alabama opened in Tuscaloosa in 1859 and offered a two-year program until 1945, when its facilities and most of the faculty were relocated to Birmingham. Jefferson Hospital, shown here, was built in 1941 and provided a joint four-year program with nearby Hillman Hospital. In 1924, UA alumnus Dr. Roy Rachford Kracke, former professor of pathology and bacteriology at Emory University School of Medicine, was appointed dean.

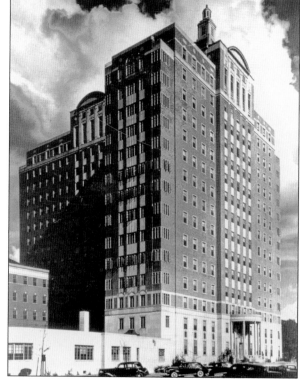

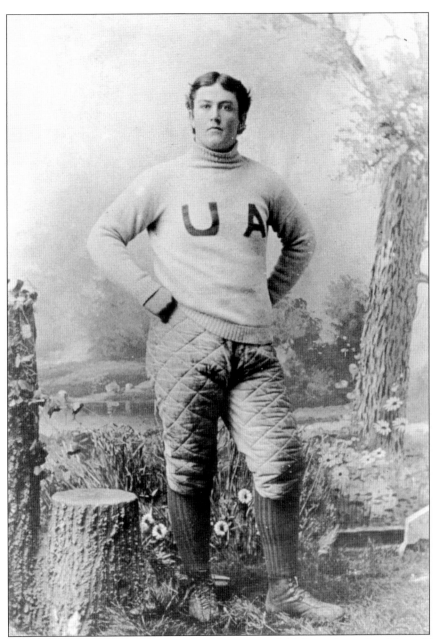

William "Bill" Gray Little transferred to the University of Alabama law school from Phillips-Andover in early 1892. Armed with a pigskin ball, shoes with cleats, and dozens of stories about an exciting new sport sweeping the country, his demonstrations quickly became training sessions for fellow students. The cadets immediately took to football, and by the end of the year, so had the school. The university established its first team of 19 players with ease. Little was named team captain and Eugene Beaumont was appointed coach. Football joined preexisting sports including baseball, wrestling, tumbling, sparring, fencing, tennis, and other forms of competitive physical activity. In 1915, the university built its first freestanding gymnasium. The facility, named Little Hall in honor of Bill Little, had a spectator gallery and was used for male sports and exercise, storing trophies, and special activities. The building currently houses the School of Social Work.

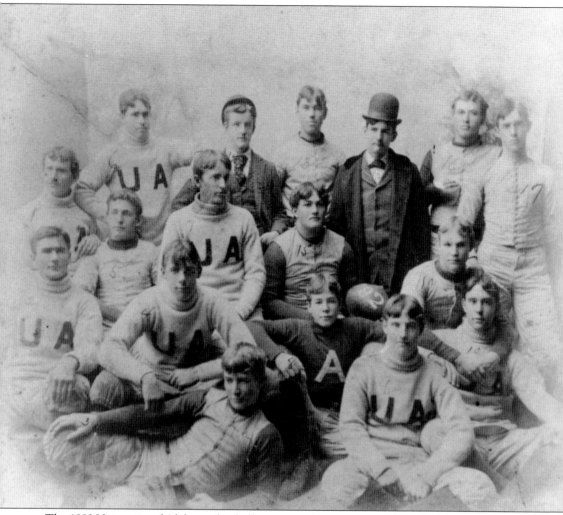

The 1892 University of Alabama football team members are pictured here. They are, from left to right, (first row) Burr Ferguson and George Herbert Kyser; (second row) David Allison Grayson, Allan Gautier McCants, William Mudd Walker, and Thomas Sidney Frazer; (third row) Frank Marion Savage, William Brockman Bankhead, captain William Gray Little, and Samuel Whilden Henderson; (fourth row) Eli Abbot, Robert Edmund Boyle, manager Felix Tarrant Bush, Henry Merrill Pratt, coach Eugene Beaumont, Robert Emmet Lee Cope, and Daniel Holt Smith. Other team members Mitchell Porter Walker, Christopher C. NeSmith, Bibb Graves, and Daniel Bascom Johnston are not pictured. Despite the favor afforded to baseball, wrestling, tumbling, sparring, tennis, fencing, and other physical activities among cadets during the 1880s, football became increasingly popular on campus. The squad was known as the "Cadets," the "Crimson White," or the varsity. After the 1907 season, the team was referred to as the "Crimson Tide."

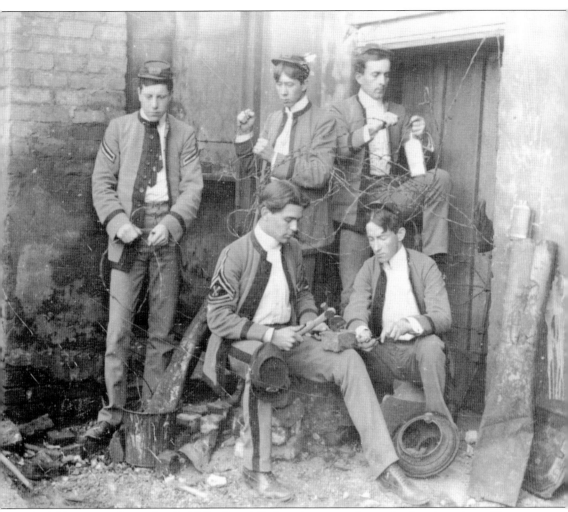

At 1:30 a.m. on December 7, 1900, dissatisfied students openly revolted against the military disciplinary practices at the university and the perceived preferential treatment of students of influential families. The young men launched an organized movement that included exploding fireworks, firearms, and cannon crackers, and netting the staircase to the barracks with barbed wire to prevent school officials from accessing their floors. Over the following weeks, meetings were held between faculty, students, and trustees, with students insisting cadet regulations be discontinued and Pres. James Knox Powers be disciplined. Their insurgence weakened the system and eventually led to the resignations of President Powers and Commandant James West. In this 1901 photograph, rebellion leaders reenact the strategy meeting for a *Corolla* (University of Alabama yearbook) photographer.

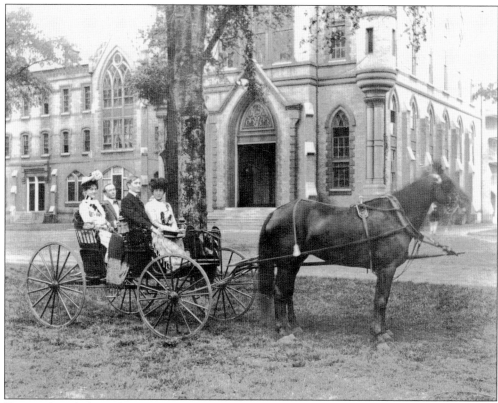

Two unidentified couples are pictured here as they pause to have a picture taken during a buggy ride in front of Clark Hall around 1901. Cornerstone buildings and structures such as Clark Hall and Denny Chimes became traditional backdrops for photo opportunities on campus among students, faculty, staff, and visitors. At the time this picture was taken, there was a perfect view of the President's Mansion directly across from Clark Hall.

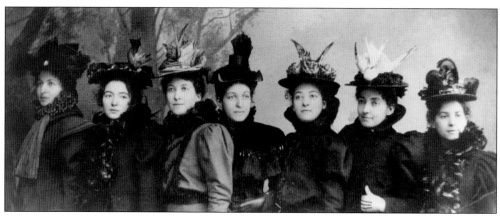

The women in this c. 1890 photograph, labeled "Hat Ladies," have been identified as the seven daughters of Burwell Boykin Lewis, but all of their names have been lost to time except one—Caroline. Lewis was a Confederate veteran, licensed attorney, former congressman, and the eighth president of the university. The first University of Alabama alumnus to become president, he was married to L. Rose Garland Lewis and died suddenly in 1885, during his fifth year as president.

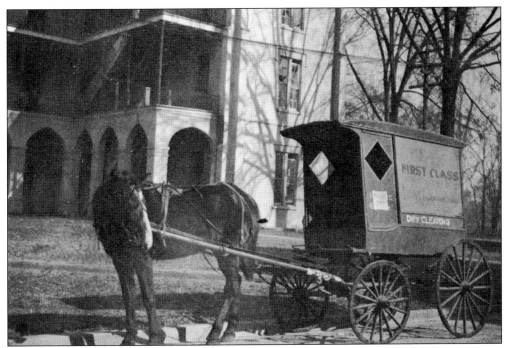

The "Greater University" plan of 1906 stipulated a yellow brick university, which led to a campus-wide transition of buildings. Clark, Manly, Garland, Barnard, Tuomey, and other halls were painted upon the adoption of the plan, with one such building visible in the background of this photograph of a local dry cleaner making a campus delivery. In May 1908, the Manufacturer's Association of Alabama initiated a campaign against the plan, insisting on the use of state-manufactured materials "for all purchases made for and in behalf of the state."

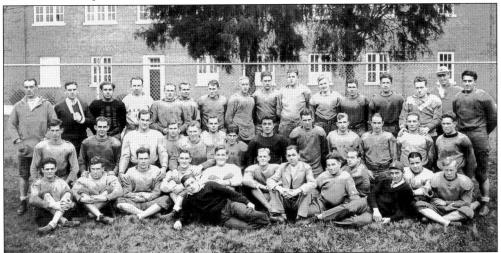

Members of the 1927 freshman football squad are pictured here with coach Wallace Wade (at right, wearing cap). Many of these men were on the 1930 national championship team during Wade's final year, when the "elephant" association began. The 1930 team was big, tough, fast, aggressive, schooled in fundamentals, and considered the best blocking team. During the championship game, an excited fan yelled from the stands, "Hold your horses, the elephants are coming," and the association was set.

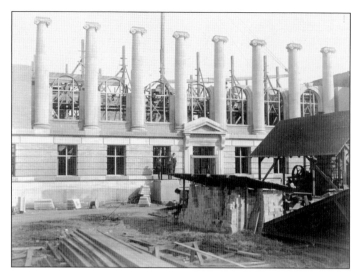

On May 28, 1907, plans were publicly announced for Smith Hall, launching the Greater University construction campaign. One year later, professor and state geologist Eugene Allen Smith participated in a ground-breaking ceremony for the science building named in his honor. The construction of Smith Hall, shown here around 1909, was completed the next year.

In 1917, the quad was a major thoroughfare, shown here with a view of the barracks (Woods Hall) toward the right and the corner of Garland Hall to the left. The Greater University plan of 1906 called for, among other things, a yellow brick university. Woods Hall was given a facelift, a stucco covering, and painted yellow to match nearby Smith, Comer, and Morgan Halls.

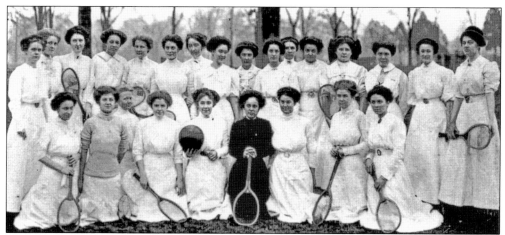

A Women's Athletic Association was formed at the university by 1910, when this photograph was taken (possibly for the yearbook). The coeds, representing the various sports of female students, also serve as a reflection of their immediate interest in athletics after being admitted as regular, full-time students in 1899 under President Powers.

Dorm life was a vital part of the social experience of students by 1900. Every wing of each floor adopted a nickname and students dressed in costumes before posing for *The Corolla* in "Stoop Pictures." This 1910 image features unidentified students from "The Ancient and Independent Brotherhood of Water Throwers." Their color was water green, their motto was "Soak 'um," and their flower was the water lily.

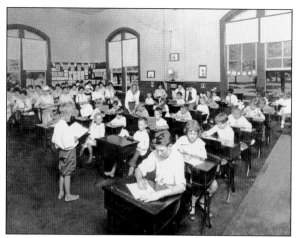

In 1915, the state Department of Education eliminated the teacher examination requirement, basing certification instead on completion of approved courses. Beginning that same year, the university's Department of Education provided the necessary instruction. A unique feature of the summer school program is shown here—called the demonstration school, it gave elementary school educators the opportunity to observe approved teaching methods in real classroom situations.

Walter Bryan Jones, shown around 1914 when he was a freshman geology student, served as state geologist and director of the Alabama Museum of Natural History from 1927 to 1961. His groundbreaking research of Indian culture of the Mississippian period at Moundville energized later interest in cave science and the establishment of Mound Park. His studies and assessments of mineral, water, and fossil-fuel energy resources laid the foundation for work that continues today.

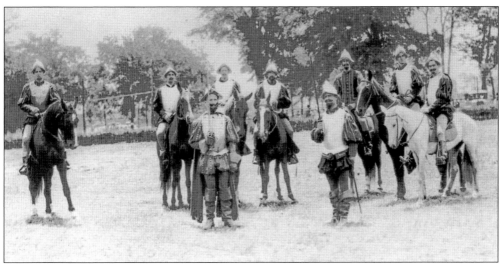

In 1931, the University of Alabama held its Centennial Celebration. The focal event was an elaborate pageant, with more than 1,000 costumed students re-creating scenes from the institution's history. At least 1,500 students participated in a spectacular finale that led into Pres. George Denny's centennial address to an audience of over 8,000 people. An opening scene in the pageant was this reenactment of Hernando de Soto's arrival in Alabama.

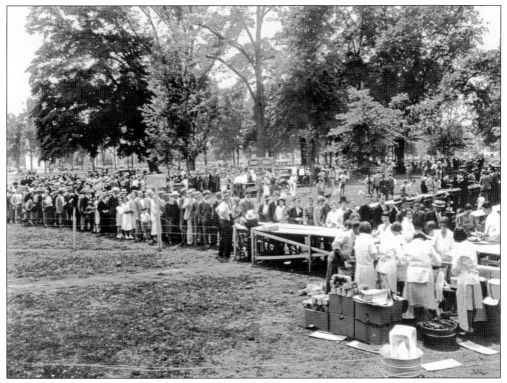

One of the best-attended social events during the centennial celebration was the barbeque held across the sprawling lawns of the university. In addition to being a major success for the centennial event, gatherings along these walkways became increasingly commonplace, taking on particular significance as Crimson Tide football games gained greater campus significance.

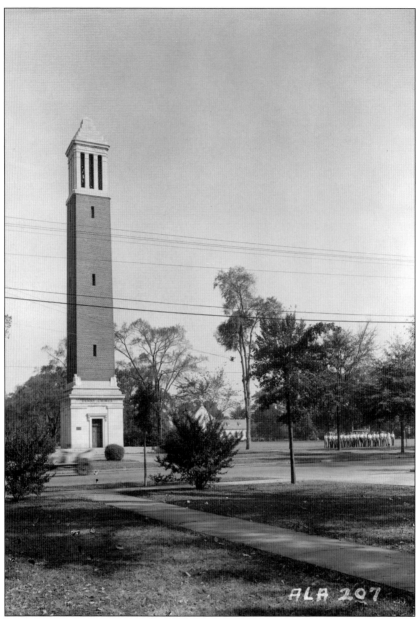

Denny Chimes (Tower) was built in the 1920s following a student-initiated campaign to honor Pres. George Hutcheson Denny (1912–1936) amid rumors that he planned to return to Washington and Lee University in Virginia. Dedicated on May 27, 1929, the tower was made of Alabama limestone and Old Virginia brick as a gesture of respect toward President Denny and his home state. With a solid brass carillon and tubular bells actuated by either a keyboard for use by a carillonneur or an automatic player for recorded music, the chimes were replaced with an electronic system in the 1940s. In 1966, the National Alumni Association donated an improved electronic system with 305 bells. When struck by a metal hammer, the nearly inaudible tones were amplified more than a million times. Denny Chimes is one of the most iconic structures on campus and the object of some of the most heartfelt student and alumni traditions, including the football quarterback placing his shoes at its base.

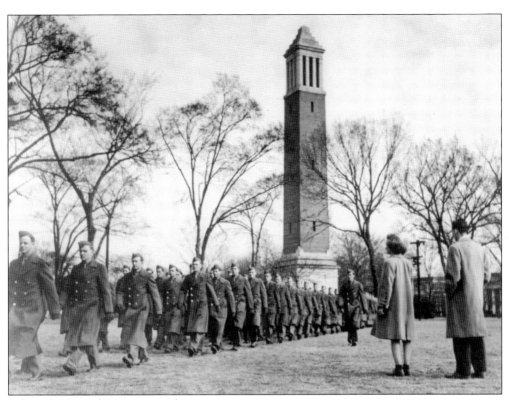

When the United States entered World War II, Alabama once again became "a university at war." Enrollment plummeted between 1941 and 1944 as students enlisted or took war jobs. The numbers soared back when 13,000 Army and Navy recruits were housed and trained on campus in 1943 alone. Cadets processing past Denny Chimes in 1943 are a stark reminder of the role and commitment of the university during the war.

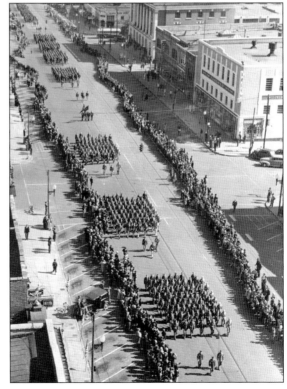

The city of Tuscaloosa turned out in record numbers to show its support for the University of Alabama's Corps of Cadets. In this photograph from spring 1943, cadets march down University Boulevard. A few highly decorated Alabama alumni include Maj. Charles W. Davis, who was awarded the Congressional Medal of Honor; Lt. Hugh Barr Miller, who received the Navy Cross; and Maj. Gen. John C. Persons, who was awarded the Distinguished Service Medal.

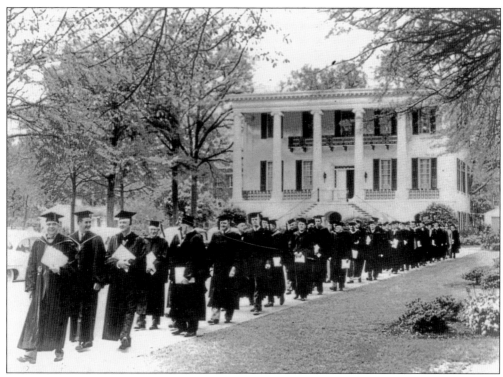

University marshal and speech department chair T. Earle Johnson led the procession from the President's Mansion to Denny Stadium for the inauguration of Frank A. Rose as the 20th university president on April 9, 1958. Rain forced the 250 attendees to shift to Foster Auditorium for Rose's induction and to hear the charge delivered by University of Virginia president Colgate W. Darden Jr.

Nellie Harper Lee was a student from 1945 to 1949, mostly studying law. She contributed to the school newspaper and humor magazine, *Rammer Jammer*, serving as editor in 1946. After she left law school because of her love of writing, her Pulitzer Prize–winning novel *To Kill a Mockingbird* was published in 1960. In this image, she poses with child actress Mary Badham on the set of the 1962 film version of her novel.

Students were traditionally actively involved with campus politics, as reflected by the April 1968 campaign signs displayed on the lawns in this photograph. Although groups held peace vigils at noon on Fridays on the steps of the Student Union building and a lively presidential election year fueled some local races, students seemed to be far more interested in university matters than local politics when this photograph was taken.

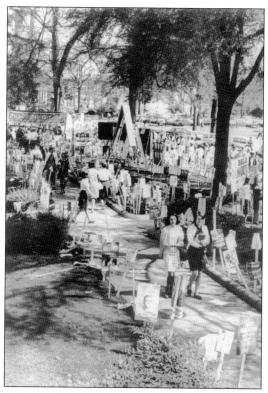

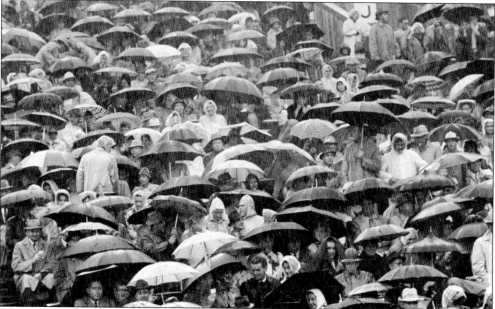

Loyal fans withstood pouring rain to witness the 1961 homecoming victory of the Crimson Tide over Mississippi State, in which Alabama won 24-0. It was a turnaround season for the team. Head coach Bear Bryant led the Crimson Tide to a string of successful seasons, retaining a 60-5-1 record between 1961 and 1966—including three national championships, four Southeastern Conference championships, two undefeated seasons, and six bowl appearances.

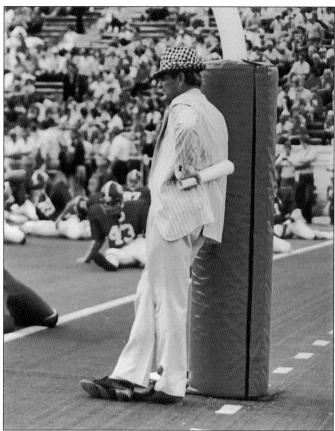

Paul William "Bear" Bryant, longtime head football coach at the university, won six national championships and 13 conference titles. He retired in 1982, holding the record for most wins as head coach in collegiate football history. His trademark was a black-and-white houndstooth hat. He routinely leaned against the goal post during pregame warm-ups and held a rolled-up copy of the game plan while on the sidelines.

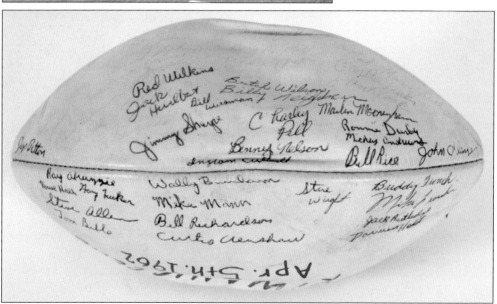

Coach Bryant and the 57 members of the 1961 University of Alabama Crimson Tide championship team signed this football commemorating the successful season. The football was presented to Kiwanis Club International president Irwin R. "Whitey" Witthuhn in May 1962 during a campus visit.

Four

DRUID CITY HOUSES

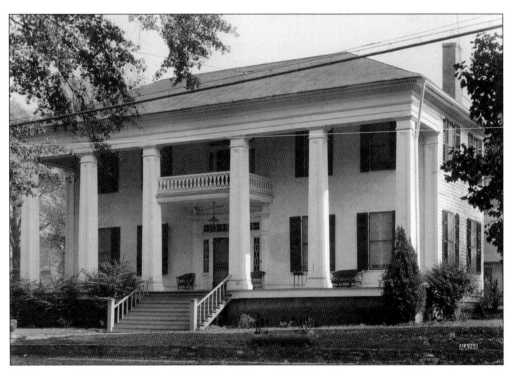

This house, built from 1835 to 1840 for Gov. Henry W. Collier, features paneled Tuscaloosa-style square columns along the front porch and a notable Greek Revival–style doorway. As governor, Collier pushed for educational reforms and oversaw the creation of the state's first facility for the mentally ill; he also entertained social activist Dorothea L. Dix when she visited Tuscaloosa. The Collier-Boone House is listed in both the National Register of Historic Places and the National Survey of Historic Sites and Buildings. (Courtesy of the Library of Congress Historic American Buildings Survey.)

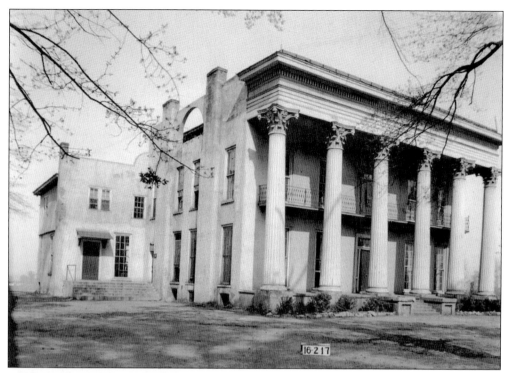

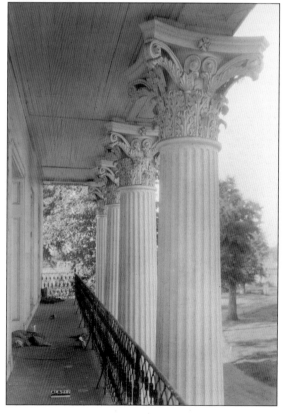

The Judge William Cochrane House was located at the present-day site of Stillman College. In 1898, the school purchased the Cochrane House, along with 20 acres of land. For many years, the house was the main building of the campus and served as a student residence. The decorative Corinthian capitals of the columns of the house were reused after it was torn down in the 1950s and currently grace the front of the college's Sheppard Library. (Both courtesy of the Library of Congress Historic American Buildings Survey.)

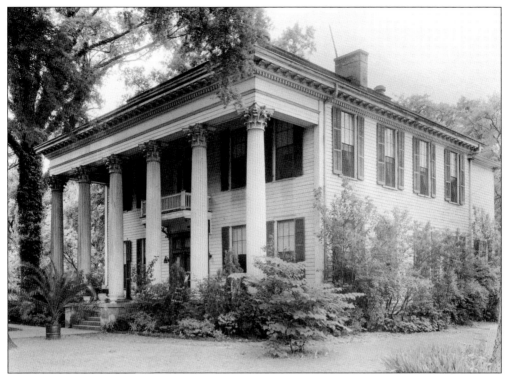

Originally located on the present-day site of the US Post Office in downtown Tuscaloosa, the Cochrane-Jones House was a Greek Revival structure that featured fluted Corinthian columns and was marked by a heavy entablature with dentil cornices. (Courtesy of the Library of Congress Historic American Buildings Survey.)

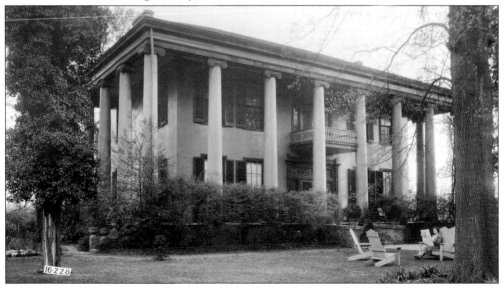

The Dearing-Swaim House is the most templar antebellum house in Alabama, boasting Ionic columns on three sides. Built by Alexander Dearing in 1835, the house is typical of high-style Greek Revival and has 13 columns. Still owned by descendants of the Swaim family, it is a cherished Tuscaloosa landmark. (Courtesy of the Library of Congress Historic American Buildings Survey.)

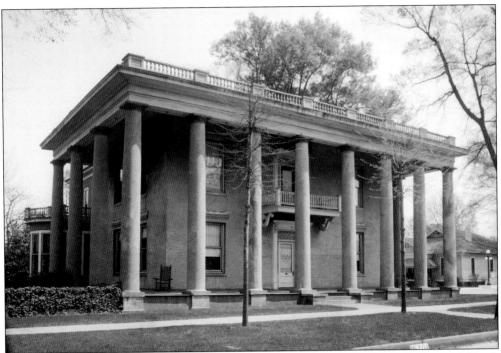

Built from 1835 to 1840 and originally located on the corner of Greensboro Avenue and Tenth Street, the Price-Eddins-Rosenau House utilized the popular trend of the mid- to late-1800s called *faux marbre* ("false marble"), in which stucco covering the brick was scored to simulate fine stone. The house also featured a Tuscan colonnade across the front and along each side. This home was scored to look like ashlar. It was torn down around 1950. (Courtesy of the Library of Congress Historic American Buildings Survey.)

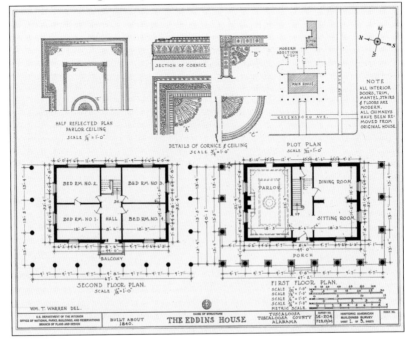

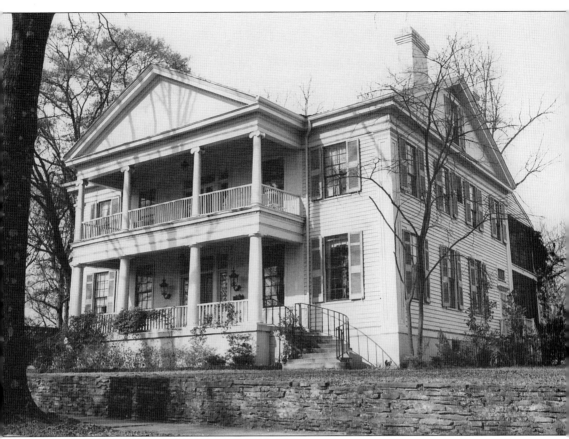

The earliest reported date of construction for the Foster-Cummings House is the late 1820s; however, there are also reports that state it was not built until 1835. Originally, the house stood alone on 10 acres of land and was three stories high. When the Dearing Place neighborhood was being developed in the 1920s, W.S. Wyman purchased the house and had it relocated to its current location, turning it to face south and removing the raised basement level. Across the front, the home features Doric columns on the first-floor porch and Ionic columns on the second-floor porch. (Courtesy of the Tuscaloosa County Preservation Society.)

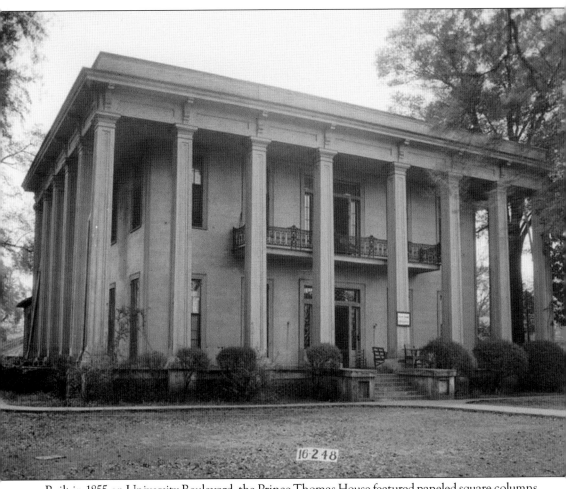

Built in 1855 on University Boulevard, the Prince-Thomas House featured paneled square columns across the front and along each side, with bracketed cornices for added ornamentation. The house was the meeting place for the University Masonic Club during the early 20th century. It was an excellent example of the transition between Greek Revival (columns) and Italianate (bracketed cornices) styles. Columns from the antebellum home were reused in several Tuscaloosa buildings, namely the Saint James Apartments and several other buildings on Riverside Drive. (Courtesy of the Tuscaloosa County Preservation Society.)

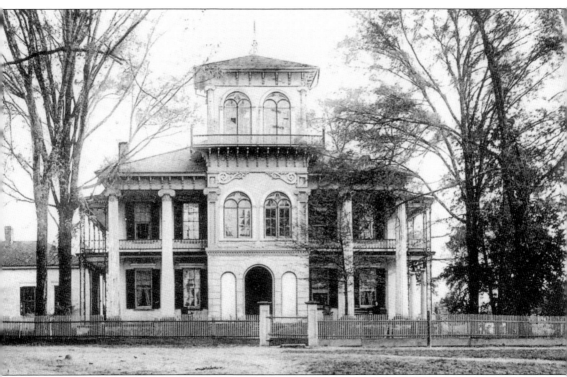

Built in 1837 as Monroe Place but better known by the surname of its builder, prominent early settler Dr. John R. Drish, the Drish House was the focal point for a plantation that bordered the city limits of Tuscaloosa. Dr. Drish remodeled the mansion in the 1850s, adding massive Doric columns and the distinctive Italianate tower. The house remained one of the finest residences in the city until 1906, when it was converted into a public school. In the 1930s, the deteriorated home was the site of the Tuscaloosa Wrecking Company and was made famous by photographer Walker Evans. His "Tuscaloosa Wrecking Company" is one of his best-known images and is housed in the Metropolitan Museum of Art in New York City. (Courtesy of the Tuscaloosa County Preservation Society.)

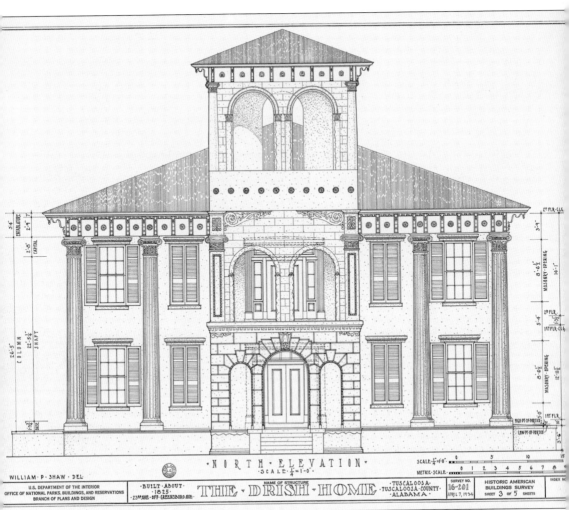

·NORTH·ELEVATION·
·SCALE·¼"=1'-0"·

WILLIAM·P·SHAW·DEL·

| U.S. DEPARTMENT OF THE INTERIOR OFFICE OF NATIONAL PARKS, BUILDINGS, AND RESERVATIONS BRANCH OF PLANS AND DESIGN | ·BUILT·ABOUT· ·1825· ·23RD·AVE·OFF·GREENSBORO·AVE· | THE·DRISH·HOME | ·TUSCALOOSA· ·TUSCALOOSA·COUNTY· ·ALABAMA· | SURVEY NO. 16-201 APRIL 7, 1934 | HISTORIC AMERICAN BUILDINGS SURVEY SHEET 3 OF 5 SHEETS | INDEX NO. |

In the 1940s, the Southside Baptist Church purchased the Drish House as a meeting site. Over the years, they built a large sanctuary abutting the house and a freestanding Sunday school building on the property. The house remained in this configuration until 1995, when the church, with a dwindling and aging population, closed its doors. The structure was leased for several years to the Heritage Commission of Tuscaloosa County and then deeded to the Tuscaloosa County Preservation Society in July 2007. The sanctuary and Sunday school building have since been removed from the property to restore the integrity of the original house. The preservation society is currently working to stabilize the home and develop a plan for an adaptive reuse of this important landmark. (Courtesy of the Library of Congress Historic American Buildings Survey.)

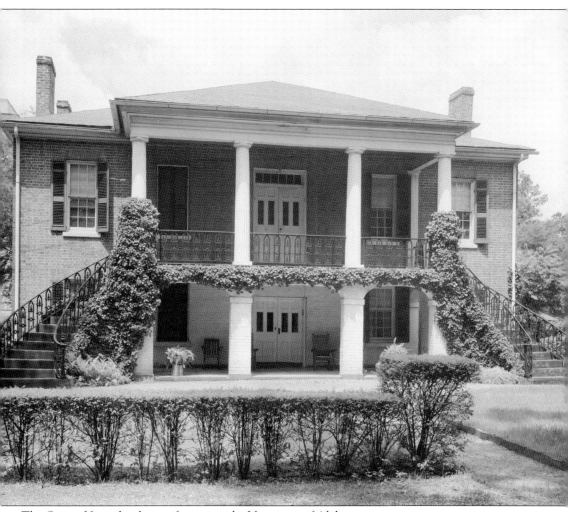

The Gorgas House has been a fixture on the University of Alabama campus since its construction in 1829. It was the first university structure and is one of only four buildings on campus that survived the Civil War. Of the four, it is the only one that was designed by state architect William Nichols. Originally utilized as a dining hall, the house became a faculty residence in the mid-19th century. Josiah Gorgas, the eighth president of the university, moved into the house with his family in 1879. The last Gorgas family member to live in the house was Josiah Gorgas's daughter, Maria Gorgas, who lived in the house until her death in 1953. The structure is currently operated as a house museum, with collections of antiques and memorabilia from the Gorgas family. (Courtesy of the Library of Congress Historic American Buildings Survey.)

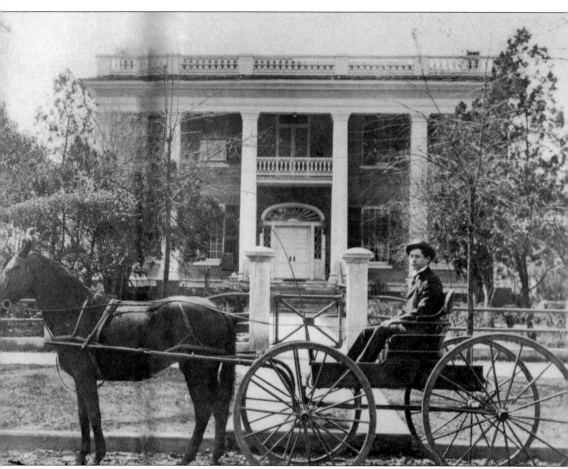

The Battle-Friedman House and its outbuildings, constructed in 1835 by Alfred Battle, once occupied an entire city block. In 1875, the house was bought by Bernard Friedman, a Hungarian immigrant and local merchant. It remained in the Friedman family until 1965, when Hugo Friedman willed it to the city. The house's exterior is stucco over brick and is painted to resemble red marble. The front porch has distinctive Tuscaloosa-style paneled square columns that were carved from whole tree trunks. Inside, elaborate plasterwork decorates the walls and ceilings of the front parlors and hallway, with the distinctive Art Deco nasturtium frieze added by the Friedmans in the early 20th century. In this photograph, Sam Friedman poses in his horse-drawn buggy. The Tuscaloosa County Preservation Society currently operates the Battle-Friedman House as a museum. (Courtesy of Helen Blackshear Friedman.)

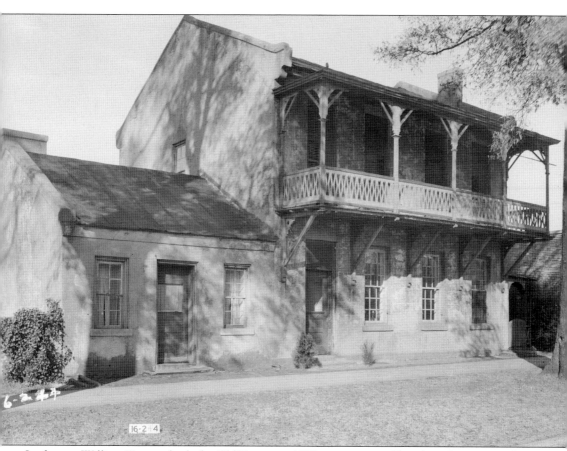

Innkeeper William Dunton built the Old Tavern in 1827 as a tavern and hotel on the stagecoach route that passed through Tuscaloosa. One of the few remaining 19th-century inns in Alabama, the Old Tavern provides a rare glimpse of early Tuscaloosa commercial architecture. As a hostelry, it was the meeting place of legislators, Confederate soldiers, and countless travelers. From 1831 to 1835, it was the temporary home of Gov. John Gayle. For 80 years, several local families occupied the structure as a private residence. The Tuscaloosa County Preservation Society acquired it through a deed in 1964. The Old Tavern was relocated to Capitol Park, three blocks from its original site, and the society began a much-needed restoration. The Old Tavern is now a museum that showcases the early history of Tuscaloosa County. (Courtesy of the Library of Congress Historic American Buildings Survey.)

Tuscaloosa's first licensed black mortician, Will J. Murphy, built this two-story Craftsman bungalow in the early 1920s as a private residence. The construction utilized materials such as bricks and windowsills that were salvaged from the old state capitol building a few blocks away, which burned in 1923. Today, the Murphy-Collins House is the home of the Murphy African-American Museum, which focuses on the lifestyle of affluent blacks during the early 1900s. (Courtesy of the Murphy African-American Museum.)

Built around 1920, the William T. Murphy House was a bungalow-style home located near University Boulevard and Hackberry Lane. Will J. Murphy, of the Murphy-Collins House pictured above, was strongly influenced by the bungalow style, and it is thought that both houses utilized salvaged materials from the remains of the state capitol building. (Courtesy of the Murphy African-American Museum.)

Built in 1820, the McGuire-Strickland House is believed to be the oldest wood frame structure in Tuscaloosa County. The home was originally located at the corner of Fifteenth Street and Greensboro Avenue. It was built for Moses McGuire, Tuscaloosa's first probate judge, and was acquired by the Tuscaloosa Presbyterian Church as a rectory in the 1850s. Milton Strickland purchased the home in 1866, and it remained in the family until 1969, when it was given to the Tuscaloosa County Preservation Society for relocation and restoration. The structure was relocated to the edge of Capitol Park and is the present-day location of the Capitol School. (Right, courtesy of the Library of Congress Historic American Buildings Survey; below, courtesy of the Tuscaloosa County Preservation Society.)

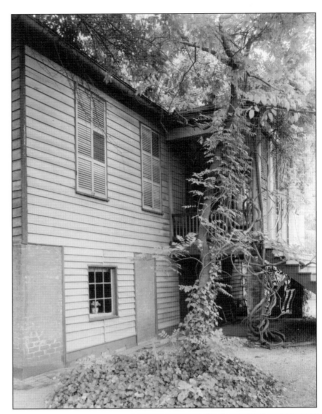

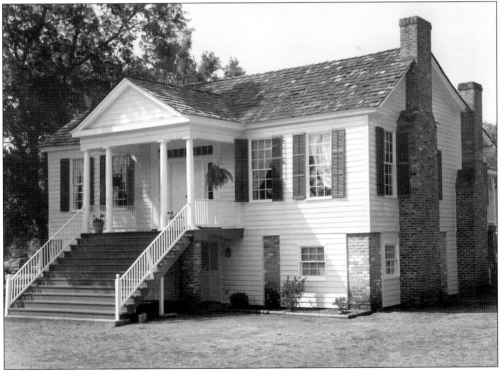

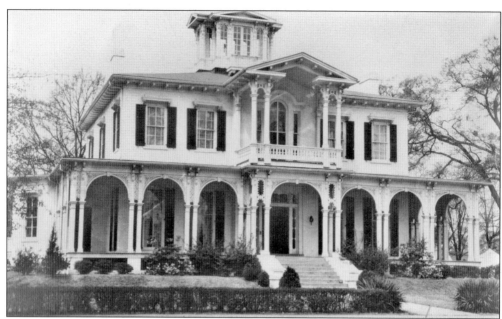

Originally called Cherokee, this magnificent Italianate house was built from 1859 to 1862 by Sen. Robert Jemison Jr., who intended it to be his townhouse. The Jemison Mansion was incomplete when the Civil War erupted, causing many finishing touches to be left undone, but the house was ahead of its time—it was the first house in Tuscaloosa to have a fully plumbed bathroom and it had its own gas plant for illumination. The Jemisons owned the house through the 1930s. During the Depression, the home was divided into 13 apartments, which all shared one bathroom. During World War II, it was acquired by J.P. and Nell Burchfield, who extensively restored the house. It later served as the county library and is now a historic house museum run by the Jemison Van de Graaff Mansion Foundation. (Courtesy of the Jemison–Van de Graaff Mansion Foundation.)

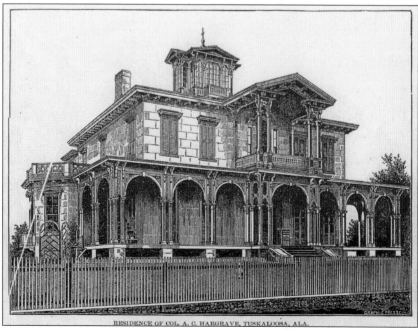

RESIDENCE OF COL. A. C. HARGRAVE, TUSKALOOSA, ALA.

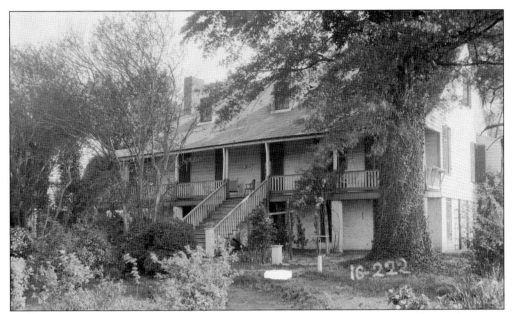

The Peck House was an excellent example of the raised cottage, which was the predominate vernacular style for Tuscaloosa, while the Greek Revival style was reserved for wealthy planters. E.W. Peck, the first "scallywag" chief justice of the Alabama Supreme Court (1867–1874) lived in this house, built in 1837, until his death. His son, Samuel Peck, Alabama's first poet laureate, lived in the house after his father's death and passed away in 1938. (Courtesy of the Library of Congress Historic American Buildings Survey.)

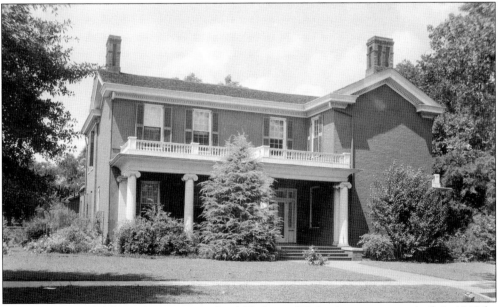

The Martin-Randolph-Marlowe House, a brick T-planned Federal structure, was built in 1840 for Gov. Joshua Martin (1845–1847), who was the last governor to serve while Tuscaloosa was the state capitol. The house also served as the Reconstruction-era home of Ryland Randolph, local editor and head of the Ku Klux Klan. The Martin-Randolph-Marlowe House was demolished in 1964. (Courtesy of the Library of Congress Historic American Buildings Survey.)

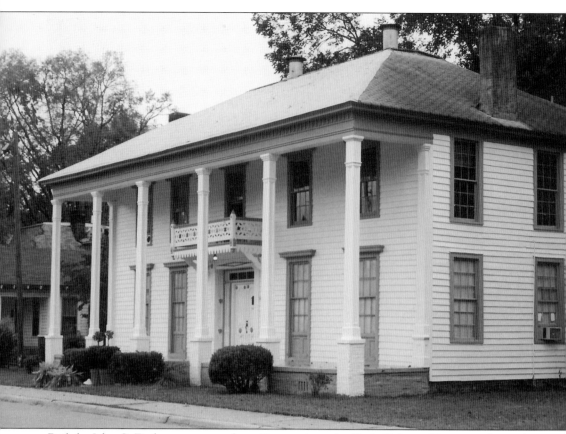

Built by John S. Fitch, a carpenter from Connecticut, the Fitch-Holman House was located in an area originally called Newtown and was one of many grand houses in that area. Fitch served as carpenter under state architect William Nichols, who designed the state capitol building. Fitch built all of the staircases in the capitol; therefore, it is no surprise that his own home boasts one of the finest and most elegant spiral staircases in Tuscaloosa. The Holman family restored the house, and it was added to the National Register of Historic Places. The Fitch-Holman House is privately owned. (Courtesy of the Tuscaloosa County Preservation Society.)

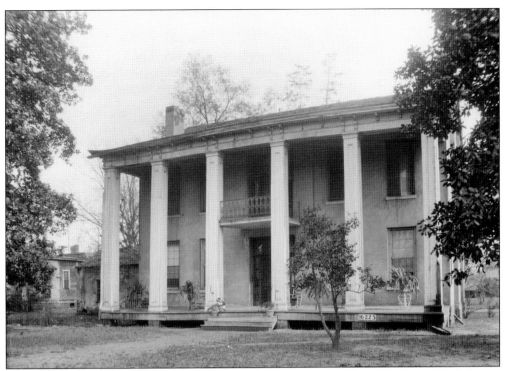

Built in 1841 for Peter Martin, brother of Gov. Joshua Martin, the Martin-Comegys-Gluck House featured the *faux marbre* technique of scoring stucco to simulate fine stone, ornamental bracketed cornices, and square paneled columns. The house was also the home of Dr. Burwell B. Lewis, a congressman and president of the University of Alabama from 1880 to 1885. The house was razed around 1940. (Courtesy of the Library of Congress Historic American Buildings Survey.)

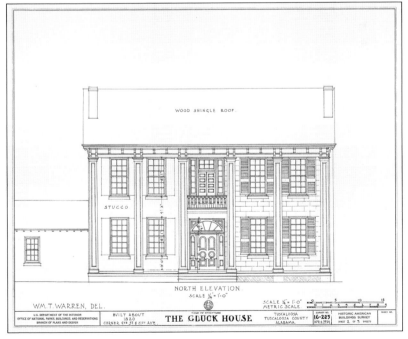

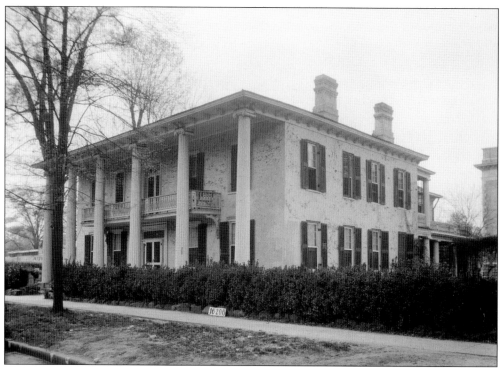

Built around 1835, the Snow House was the longtime home of E.N.C. Snow, prominent Tuscaloosa businessman and civic leader. It was also the residence of Prof. Michael Toumey, Alabama's first state geologist. The Snow House was razed in 1964 to make way for the new Tuscaloosa County Courthouse; however, the unique corkscrew staircase was saved and is currently in the County Board of Education building (the former Searcy House). (Courtesy of the Library of Congress Historic American Buildings Survey.)

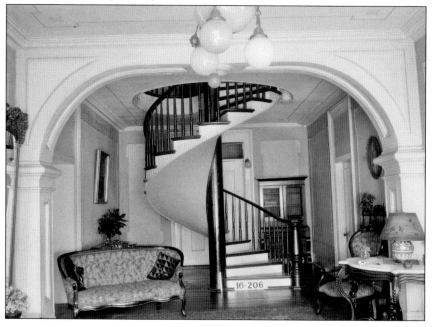

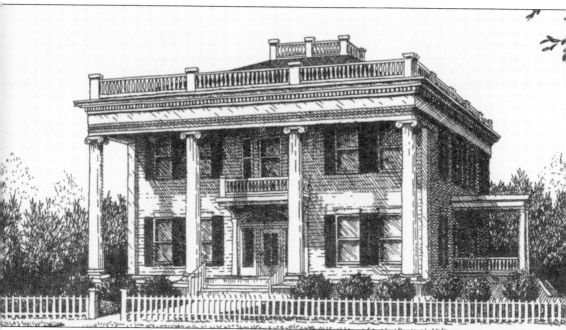

Built in 1904 by local banker and businessman George Searcy, son of Reuben and Mary Abigail Searcy, the Searcy House is an excellent example of Neoclassical architecture. George Searcy was president of Merchants National Trust Bank and was involved in the establishment of the Alabama Insane Hospital (later renamed Bryce Hospital). The house was renovated from 1986 to 1988 through the joint efforts of the County Board of Education, the Tuscaloosa County Preservation Society, the Tuscaloosa County Commission, and the Phoenix House, a rehabilitation facility. The unique corkscrew staircase from the E.N.C. Snow House is now located in this structure. The Searcy House is the location of the offices of the Tuscaloosa County Board of Education and is listed in the National Register of Historic Places. (Courtesy of the Tuscaloosa County Preservation Society.)

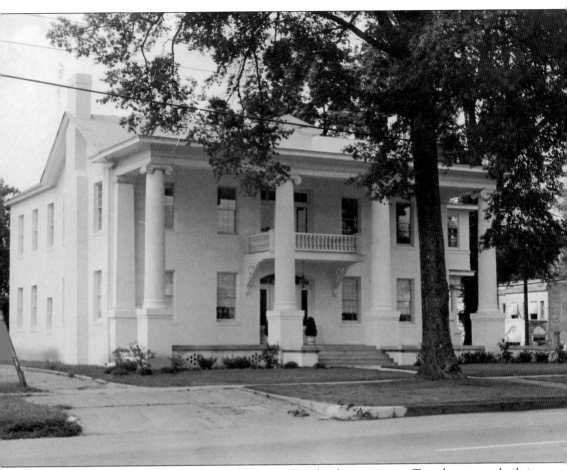

The Guild-Verner House, reputed to be the earliest brick structure in Tuscaloosa, was built in 1822 by Dr. James Guild. His son, Dr. Lafayette Guild, served as the chief medical examiner under Gen. Robert E. Lee during the Civil War. C.B. Verner remodeled the house in the early 1900s in the Neoclassical Revival style. During the remodeling, the house's brick exterior was covered with stucco and the Ionic columns were added across the front. The house is located on University Boulevard and is the current site of the offices of S.T. Bunn Construction Company. (Courtesy of the Tuscaloosa County Preservation Society.)

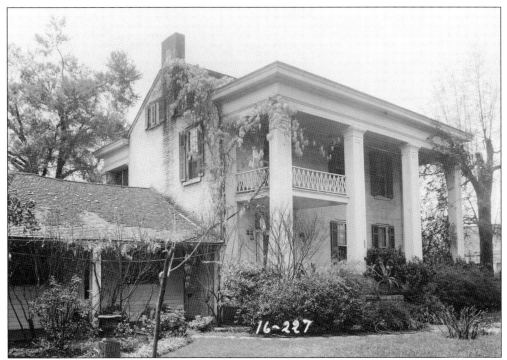

The Washington-Moody-Warner House, built around 1821 on the edge of the original city limits, has seen many changes over the years. In 1832, prominent merchant and landowner David Scott purchased the one-story structure and added the two-and-a-half-story brick Federal addition. The house experienced further changes under Dr. William Hester, who added front and back porches, making it look the same from both sides. For this reason, one of the house's occupants named it Janus Place after the mythological Roman god with two faces. The house was renovated in 1976 by the David Warner Foundation and once showcased the Westervelt-Warner collection of American art. It is listed in the National Register of Historic Places and is now a private residence. (Courtesy of the Library of Congress Historic American Buildings Survey.)

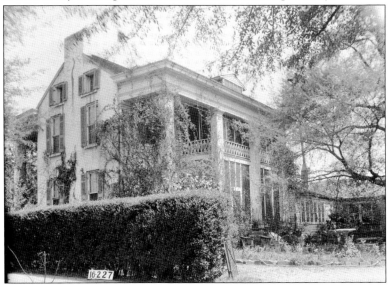

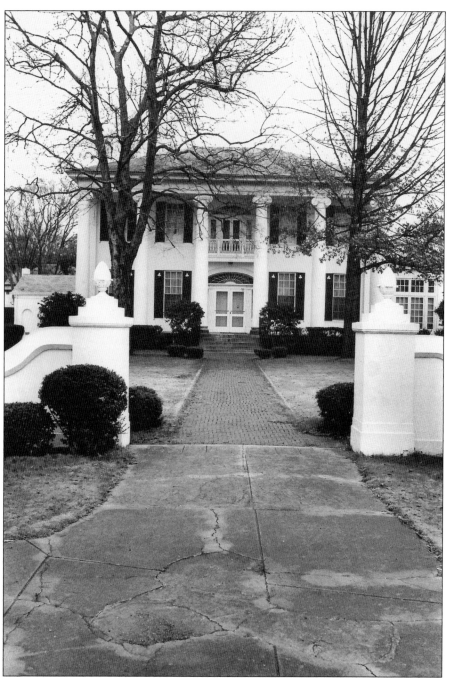

Also called the "Governor's Mansion," the Greek Revival–style Dearing-Bagby House was built in 1834 for local merchant and riverboat captain James H. Dearing. Gov. Arthur Bagby lived in the house during his tenure as governor from 1837 to 1841. The house was renovated in 1922 for Dr. Seaborn Deal by noted architect David Oliver Whilldin, who added a sunroom. After Dr. Deal, the house ceased to be a private residence and was converted into a faculty club for the University of Alabama by the H.D. Warner family in 1944. The structure is more commonly known as the University Club. (Courtesy of the Tuscaloosa County Preservation Society.)

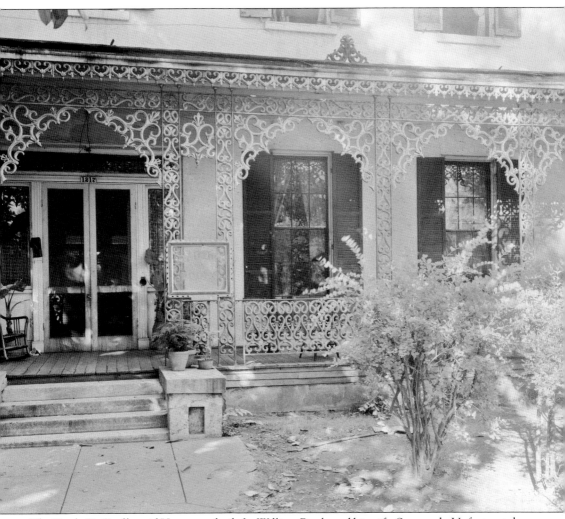

The Battle-DeGraffenreid House was built for William Battle and his wife, Susannah. Unfortunately, the Battles fell victim to the recession of 1857 and had to move out of their home and in with William's parents, Alfred and Millicent Battle (of the Battle-Friedman House). The two-story Battle-DeGraffenreid House featured an intricate cast-iron railing on the front porch and a veranda, and originally stood just across Thirteenth Street from the Jemison–Van de Graaff Mansion. It was razed in the 1960s to make way for the Greensboro apartment complex. (Courtesy of the Library of Congress Historic American Buildings Survey.)

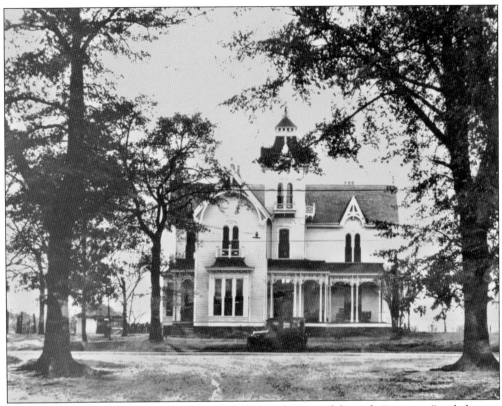

The Kennedy-Foster House was built around 1870 and is one of the only "mansion"-style houses constructed in the decades following the Civil War. The house is an exceptional example of Victorianism, with detailed gingerbread ornamentation and excellent craftsmanship, and is a true Tuscaloosa landmark. (Courtesy of the Tuscaloosa County Preservation Society.)

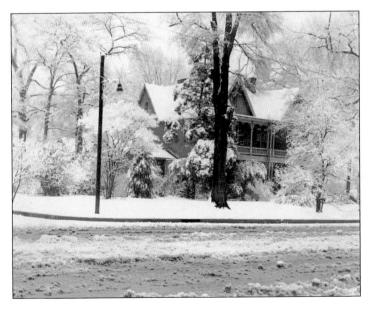

The Anders-Nicholsons house is shown covered in a thick blanket of snow after one of Tuscaloosa's uncharacteristic winter storms. The home was built in the 19th century on Broad Street (University Boulevard). It was commonly referred to as the "Buck Boarding House."

Five

AROUND T-TOWN

Tuscaloosa is well
known by its nickname,
T-Town, as evidenced
in this Coca-Cola sign
painted on the side
of a building near a
thoroughfare entering
the city. Commonly
expressed in conversation
and literature, "T-Town"
is also used in the
names and marketing of
numerous local, national,
and international
businesses. (Courtesy
of the Library of
Congress, Prints and
Photographs Division.)

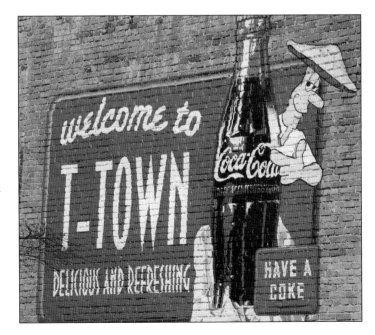

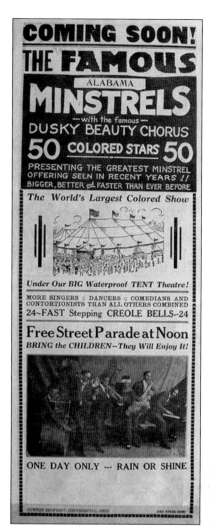

This minstrel show advertisement poster boasts of the talent of African American entertainers from Alabama. Posters such as this one appeared on storefront exterior walls and posts in the 19th century. While the 50 performers were from Alabama, "with substantial representation of Blacks from Tuscaloosa," the show was organized through an Ohio-based group.

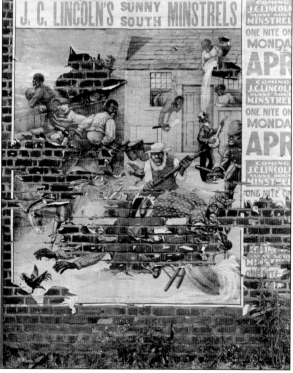

Minstrel show posters were commonplace, placed in frequented locations. They appeared on storefront exterior walls and posts on the sides of buildings in the 19th century. This remnant from the past announced shows that included African Americans from the region of Alabama that included Tuscaloosa. (Courtesy of the Library of Congress, Prints and Photographs Division.)

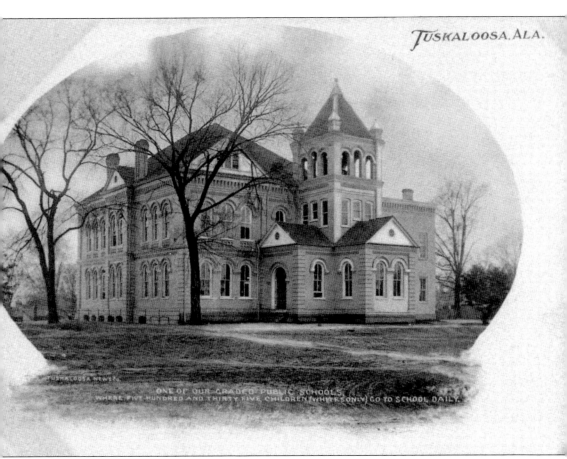

The Stafford School was located at the southwest corner of Ninth Street and Twenty-second Avenue. Prof. Samuel M. Stafford and his wife, Maria, a teacher from Vermont, purchased the property in 1859 after he resigned from the University of Alabama because of ill health. They operated the school until 1873 when, after Professor Stafford's death, Maria Stafford moved to Brooklyn to live with her daughter. The school declined until 1885, when the Tuscaloosa school system was established and the building was rented. The Stafford School became Tuscaloosa's first public school and was used as such until 1954. The majestic building was demolished in 1955 to make way for a hotel. (Courtesy of the *Tuscaloosa News*.)

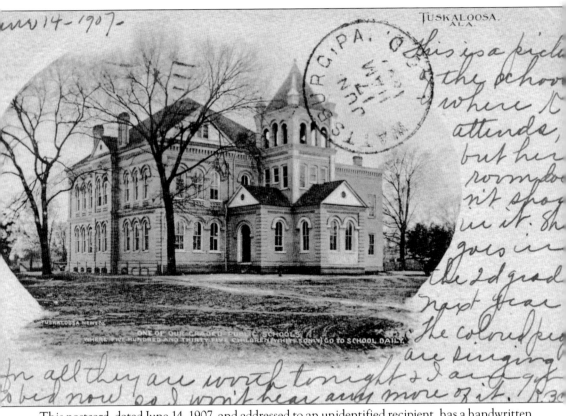

This postcard, dated June 14, 1907, and addressed to an unidentified recipient, has a handwritten message from K.B.C. in Wattsburg, Pennsylvania, commenting about the attendance of "K" at the pictured Stafford School. The postcard's printed inscription reads: "One Of Our Graded Public Schools Where Five Hundred Thirty Five Children (White Only) Go To School Daily." The postcard gives a sense of the personality of the writer in light of the fact that a postcard message is easily assessable and essentially public. It reads: "This is a picture of the school where K. attends, but her room doesn't show in it. She goes in the 2nd grade next year. The colored people are singing for all they are worth tonight and I am going to bed now so I won't hear any more of it."

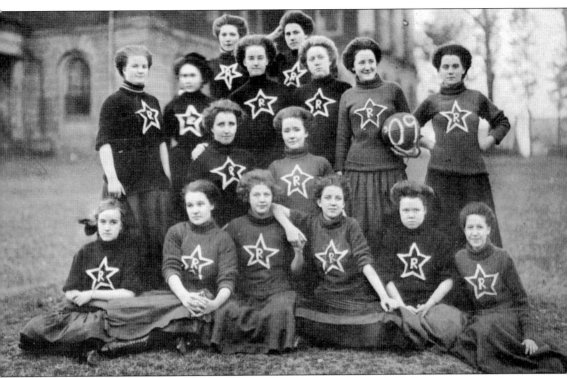

The members of the 1909 basketball team at Alabama Central Female College pose on the lawn in front of the former state capitol. After the seat of government was moved from Tuscaloosa to Montgomery in 1847, the capitol and its furnishings were deeded to the University of Alabama. In 1957, the university board of trustees leased the building for 99 years to the newly formed female college to serve as the main campus building. Founded by leading Baptists of the Tuscaloosa Association, it was considered "a high grade school for young ladies." Another building was constructed on the west side of the old capitol in 1861 to be used as a dormitory, recitation rooms, and other purposes. The college maintained departments of instruction in liberal arts, music, drawing, painting, and ornamental work, later adding courses in elocution, education, and business. (Courtesy of the Tuscaloosa County Preservation Society.)

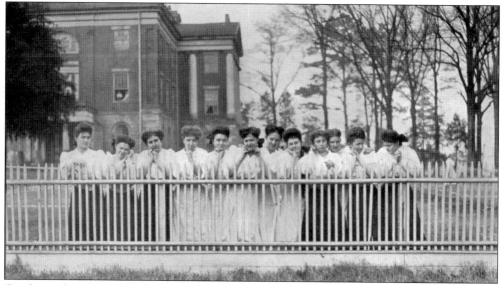

Coeds are shown in 1906 along a fence outside the main building at Alabama Central Female College. The photograph was possibly taken for the yearbook *The Fern and Violet* or *The Baptist Encyclopedia* in recognition of the college's 50th anniversary. Classes began in the fall of 1856. From the school's inception, the state Baptist organization routinely applauded both the decision to found the college and its success. (Courtesy of the Tuscaloosa County Preservation Society.)

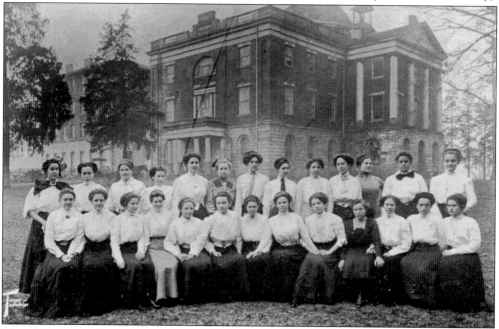

This photograph of the 1910 junior class at Alabama Central Female College shows the old capitol in the background. Its formal nature suggests it was taken for the college yearbook or other school purpose. The photograph indicates that despite uniforms, the students enjoyed some freedom in their attire, as seen in variations of their overall dress and accessories—especially the oversized bow worn by the student at the far left end of the second row. (Courtesy of the Tuscaloosa County Preservation Society.)

Schoolchildren exit the museum at Moundville in 1939. They are among the thousands who visit the site each year. Moundville Archaeological Park Museum is operated by the University of Alabama Museum of Natural History. Archeological investigations are performed under the direction of the university's Department of Anthropology.

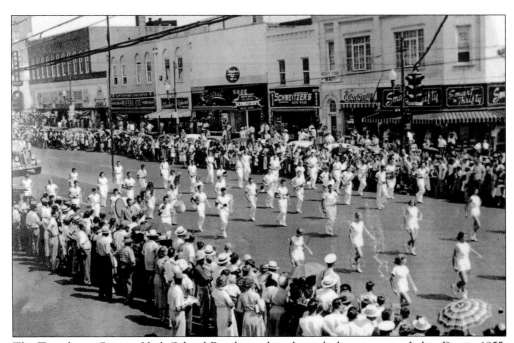

The Tuscaloosa County High School Band marches through downtown on Labor Day in 1955. That same fall, the new Druid High School building opened, placing most of its African American students at a single location. Fifteen years later, the two schools merged according to federal desegregation regulations, forming Central High School and establishing a model approach later used in junior high and elementary schools.

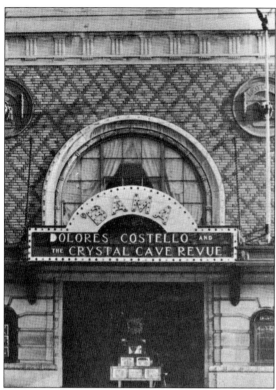

Built in 1923 by architect David Oliver Whilldin, the architect of the adjacent Merchants Bank and Trust (today RBC), the Bama Theatre featured smooth ashlar stone at the ground level and intricate diamond pattern brickwork above the marquee. News accounts described the interior as having an Egyptian decorative theme. The theater seated 1,000 and opened in November 1924. (Courtesy of the Tuscaloosa County Preservation Society.)

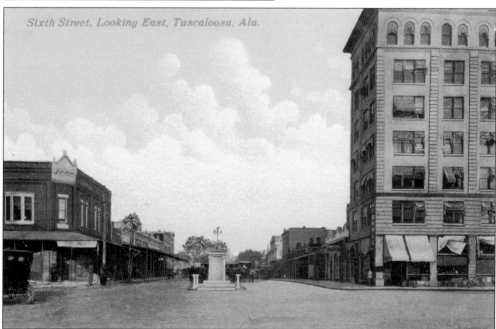

This fountain, originally used for watering horses, was taken down in the 1920s. The area around Sixth Street was a place of social congregation during the antebellum and Victorian periods. The two buildings shown on either side of Sixth Street are still standing and are now commercial properties. (Courtesy of the Tuscaloosa County Preservation Society.)

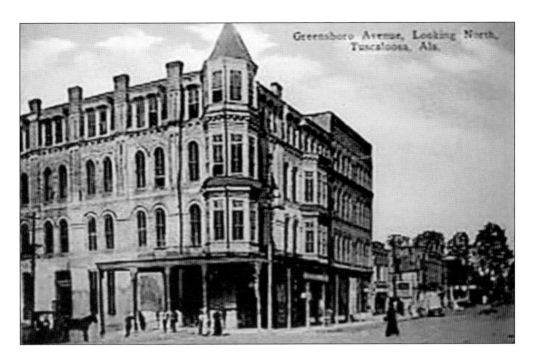

Located on the corner of Greensboro Avenue and Sixth Street, the McLester Hotel utilized the Second Empire style popular from 1855 to 1885 and featured a tall turret and distinctive U-shaped window crowns. There was also a saloon on the first floor. The building was renovated in the 1920s, but retained the unique windows. It was torn down in 1964 to make way for modern commercial space. (Above, courtesy of the Tuscaloosa County Preservation Society; below, courtesy of the *Tuscaloosa News*.)

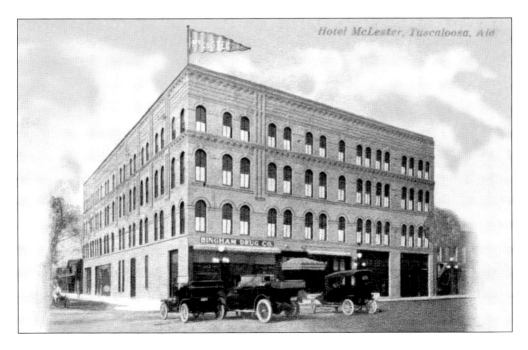

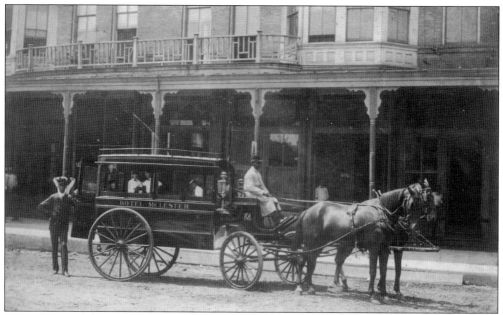

Travelers to and from the McLester Hotel enjoyed the comfort and hassle-free mobility of a horse-drawn cab, an indication of the courtesies available to guests. It was also an effective advertising tool for the establishment while moving about the streets or parked outside the hotel, as seen in this c. 1900 photograph.

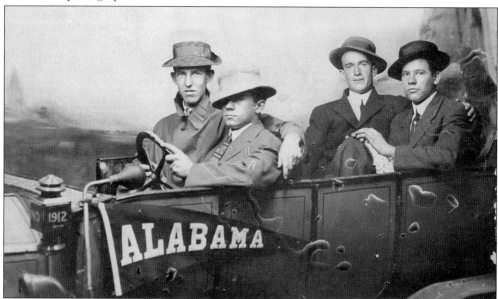

This 1912 photograph shows Memnon Tierce at right, seated behind driver William Perry; the other two passengers are unidentified. The son of Eugene B. Tierce and Veturia Scales Tierce, Memnon lived in a home just south of North River (Lake Tuscaloosa) on Highway 69 North (Crabbe Road) with siblings Collier, Victor, Festus, and Octavia. Ancestor Jonathan Tierce arrived in Tuscaloosa in 1816. Six roads and a creek are named after Tierces; Memnon Tierce II and other Tierces still reside in the city. Author Katherine Richter is Memnon's great-granddaughter. (Courtesy of Memnon Tierce II.)

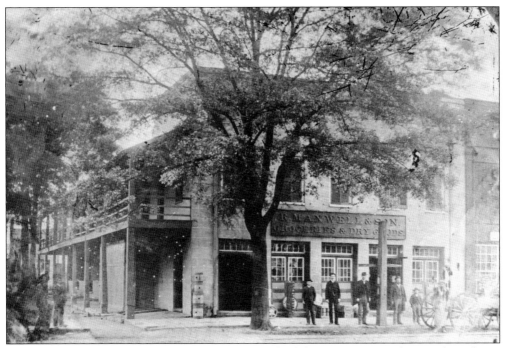

This is one of few known photographs of one of the multiple businesses in Tuscaloosa and Northport owned by British-born James Robert Maxwell. Maxwell immigrated to Tuscaloosa around 1850 and immediately put resources into businesses and a plantation that he purchased in 1852. J.R. Maxwell and Son Groceries and Dry Goods Store—located downtown—sold "everything from dresses to feed." (Courtesy of the Library of Congress, Prints and Photographs Division.)

This c. 1880 view of Greensboro Avenue was taken from the intersection of Broad Street (now University Boulevard), looking south. It is the only known view of the 1845 courthouse, though only the clock tower is visible above the trees at left. The avenue is lined with the city's signature water oaks.

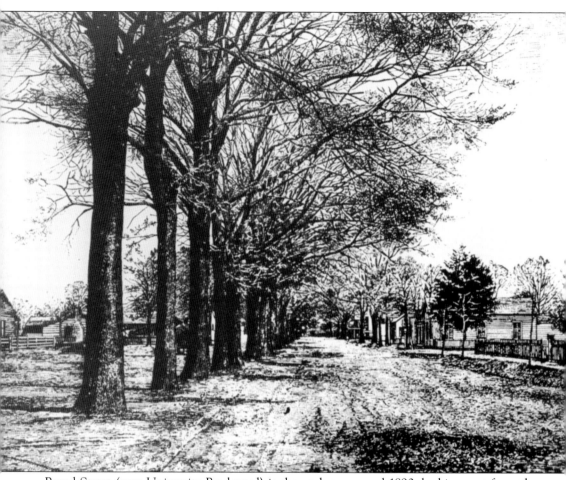

Broad Street (now University Boulevard) is shown here around 1890, looking east from the vicinity of Capitol Park. Mature oak trees are evident on the median. Water oaks were heavily planted throughout the city in its early days and were the basis for Tuscaloosa being called the Druid City.

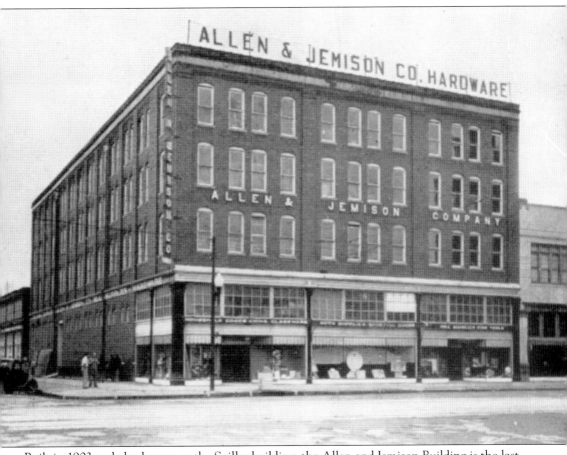

Built in 1903 and also known as the Spiller building, the Allen and Jemison Building is the last remaining example of commercial architecture of the early 1900s in Tuscaloosa. The structure is a four-story building with thick brick walls and massive timbers from pines harvested in Mississippi. The Allen and Jemison Warehouse Company was founded in 1883 and stored cotton and traded in lumber, wood, coal, brick, and other building materials. As the company grew there was a need to expand, and when the current building was erected, it contained all the modern conveniences of the time, including steam heat and an electric elevator. The Allen and Jemison Building has been leased by the city of Tuscaloosa and will be the site of the Dinah Washington Arts and Cultural Center. (Courtesy of the Tuscaloosa County Preservation Society.)

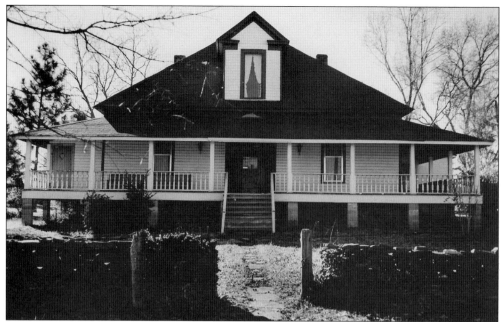

Formerly the Browne House, the Plantation Restaurant was located on Hargrove Road East. It was built in 1900 for the Browne family, and trees growing on the site were used in its construction. The raised cottage featured a wide porch that extended around the entire structure. Unfortunately, the house burned beyond repair in 1979. (Courtesy of the Tuscaloosa County Preservation Society.)

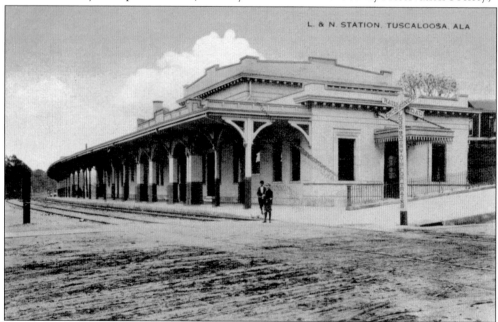

Originally the Louisville & Nashville train station for Tuscaloosa, the L&N depot was built in 1912 and became fully operational in 1913. Located on Greensboro Avenue, it was the final railroad to reach Tuscaloosa. Although it ran for only 20 miles, the train reached important Brookwood coal mines and connected to the larger rail system. The depot has distinctive features such as decorative tile floors, marble walls, and a large gasolier in the main room.

The Tuscaloosa News and Masonic Hall is shown here around 1915 at the Sixth Street site, located between Christ Episcopal Church and the Bama Theater. Known over the years as the *American Mirror*, the *Tuscaloosa Chronicle*, the *Tuscaloosa Times*, and the *Tuscaloosa News*, the daily newspaper has served Tuscaloosa and west Alabama since June 1818. The paper moved from this site to a location three blocks east on Sixth Street and then to its current location on Jack Warner Parkway.

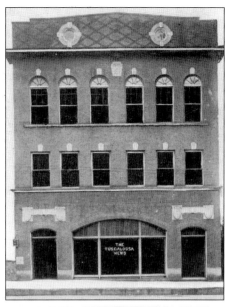

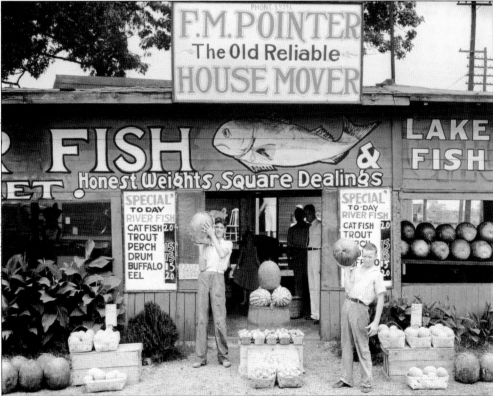

Acclaimed documentary photographer Walker Evans captured this scene of a southern fish market along an unidentified road in Tuscaloosa County "in a direction leading toward Birmingham" in 1936. Evans became known for his Depression-era photo essays of rural subjects, especially in the Deep South, and scenes photographed for the Farms Security Administration (FSA). (Courtesy of the Library of Congress, Prints and Photographs Division.)

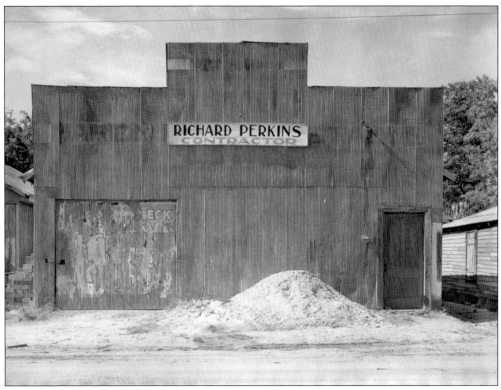

This contracting building was located on an unidentified road a few miles from Tuscaloosa, near Moundville. Photographed in 1936 by Walker Evans for the FSA, it appears to have recently shut down, still showing signs of operation such as a mound of what Evans believed was a mixture of sawdust and dry cement and stacked bricks along the side. (Courtesy of the Library of Congress, Prints and Photographs Division.)

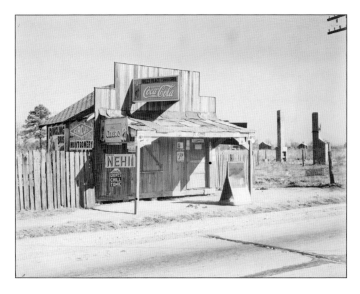

This Walker Evans photograph of a closed roadside store was taken between 1935 and 1936. A part of his extensive documentation of the Depression era in the south, it captures the isolation of and economic impact on small businesses in the region. The store was located on a highway outside Tuscaloosa headed south toward Montgomery. (Courtesy of the Library of Congress, Prints and Photographs Division.)

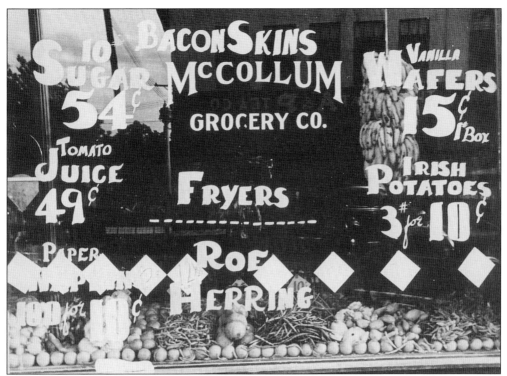

A close-up of the McCollum Grocery window, photographed by Walker Evans between Tuscaloosa and the outskirts of Greensboro, reveals the price of food staples such as potatoes, poultry (fryers), tomato juice, and sugar—a rare commodity during the Depression. (Courtesy of the Library of Congress, Prints and Photographs Division.)

This view of Northport looks northwest and shows City Cafe, a popular diner among Tuscaloosa residents and students. Northport is adjacent to Tuscaloosa on the Black Warrior River and is part of Tuscaloosa's statistical metropolitan area. It is home to the annual Kentuck Festival of the Arts, where artists show and sell works to thousands of attendees. (Courtesy of the Library of Congress, Prints and Photographs Division.)

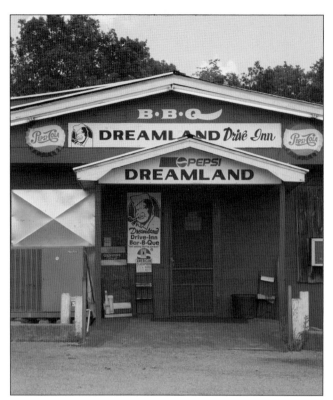

When it comes to barbeque, Dreamland is a Tuscaloosa icon. With seven restaurants in Alabama and Georgia, this original site remains a favorite of locals and travelers who exit Interstate 20 at MacFarland Boulevard in the city specifically to dine there. (Courtesy of Dreamland Barbecue.)

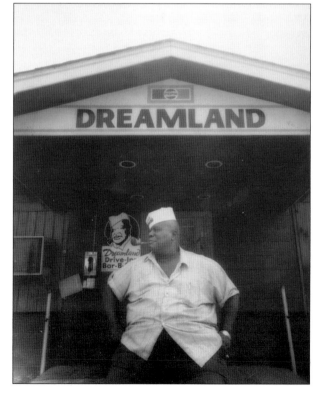

John "Big Daddy" Bishop opened his first Dreamland Cafe next to his home in 1958, two miles from the intersection of Highway 82 and Interstate 59, just south of Tuscaloosa, in an area known as Jerusalem Heights. Serving essentially pork ribs, white bread, and Bishop's popular original sauce at the original location, additional items are available at most of the seven other restaurants. (Courtesy of Dreamland Barbecue.)

On August 22, 1923, the historic capitol building was destroyed by fire. In the 1930s, the site was cleared for use as a park. Capitol Park, located west of Twenty-eighth Avenue and north of Sixth Street, contains reconstructed architectural features of the original building. Actual bricks and stonework from the structure outline the ground floor and rotunda along with massive columns repaired and replaced on their original sites.

As bordering states fell, Alabama iron became critical to the survival of the Confederacy. During the final two years of the Civil War, Alabama's furnaces produced 70 percent of the Southern iron supply. On March 31, 1865, federal troops known as Wilson's Raiders destroyed Tannehill Furnace, located on the eastern edge of Tuscaloosa County. They also torched adjacent factory buildings, slave cabins, a large gristmill, a tannery, and a storehouse.

The exterior of the Alston Building was patriotically decorated for Tuscaloosa's 1916 centennial. The Tuscaloosa Centennial Celebration was held in 1916 (rather than 1919) to mark the 100th year since the arrival of the first white settlers in the area. The pageantry was highlighted with a parade down Broad Street (University Boulevard). School bands, the Northport Civic Club, and the Zamora Shrine Drill Team were among the many participants.

This group posed on Bryce Hospital's field in the 1920s. Bryce was no longer in a position to allow private aircraft to land on the property shortly after this photograph was taken. The same situation existed at the University of Alabama, where planes had also been permitted to land and which was also no longer an option for pilots, both sites being state-owned.

In this c. 1950 image from near Lake Tuscaloosa, four unidentified men pose casually—but with pride—with a prize catch. From sailing to skiing to championship bass fishing, Tuscaloosa County is something of a mecca for water sports. Lake Tuscaloosa, Holt Lake, Lake Lurleen Wallace, Lake Nichol, Oliver Lake, and the Black Warrior River all provide recreational opportunities.

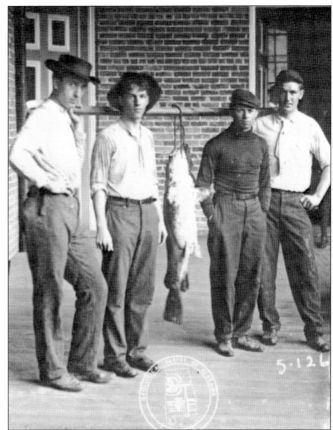

Summertime canoeists and boaters enjoy a day of leisure on the gentle rapids of the Black Warrior River in the 1920s. The four men in the center foreground are possibly members of a rowing team and may be the reason for the photograph.

The Swimming Lake opened in the summer of 1936 at the university and immediately became a favorite social and recreational spot on campus. Its popularity continued over the decades, as evidenced in this 1957 photograph.

This early 1960s image shows swimmers cooling off during a typical hot summer day at the Riverside Swimming Pool in Tuscaloosa. Recreational facilities, public and private, were still segregated when this photograph was taken, and swimming pools were of particular concern. Southern whites considered pools used by African Americans to be "contaminated."

Six

INDUSTRY AND LABOR

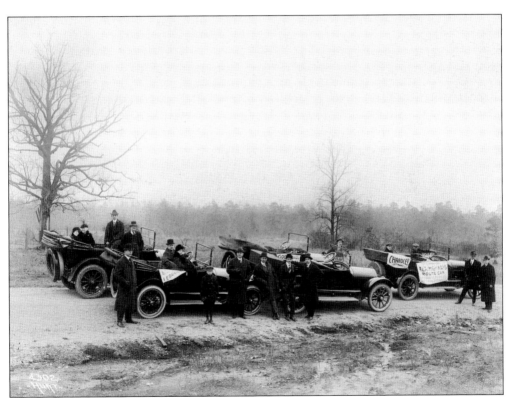

Members of the Good Roads Association park along a Tuscaloosa road as part of a Good Roads promotional tour in the 1900s. Standing and seated in designated highway route cars with signage advancing their cause, members of the association were interested in improving road conditions and mobility along the nation's highways, particularly in rural areas. Gov. William W. Brandon was active in the group and served as president in the early 1920s.

This drawbridge crossed the Black Warrior River and connected downtown Tuscaloosa and downtown Northport. The two-lane bridge was built in 1922 and was considered spectacular at the time. The old drawbridge was a vertical lift span bridge, with a central span that lifted to allow water traffic to pass. It joined a succession of bridges between the two cities. The first bridge was built in 1834 by a slave, Horace King, and was replaced in 1852 because of tornado damage. The second bridge was destroyed by Union troops in 1865, and King, now a free man, engineered another wooden span in 1872. A three-span iron bridge was built in 1882 and replaced with a swing-span bridge in 1895, which survived until the drawbridge was constructed. The drawbridge was demolished in 1973 after the completion of the Hugh Thomas Bridge.

Farming families of rural Tuscaloosa County endured a deepened state of poverty and isolation during the Great Depression. Everyone had arduous daily chores, including children, often with little return. This photograph presents a rare depiction of a mother and her sons smiling, contrary to the often-solemn Depression-era portrayals of rural Southern subjects.

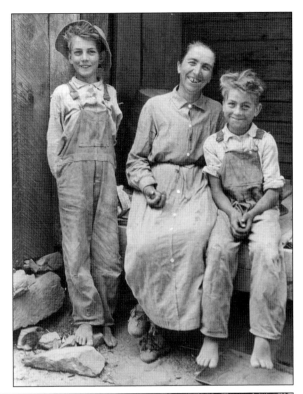

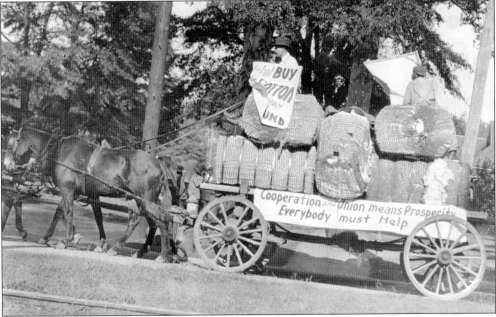

The problems associated with growing cotton were evident to farmers by 1915, around when this photograph was taken. Growing cotton was hard on the land, resulting in environmental conditions that led to soil erosion, loss of nutrients in the ground, and river issues. Cotton prices were declining, and farming the crop was labor-intensive. As a solution, farmers banded together in an aggressive marketing campaign.

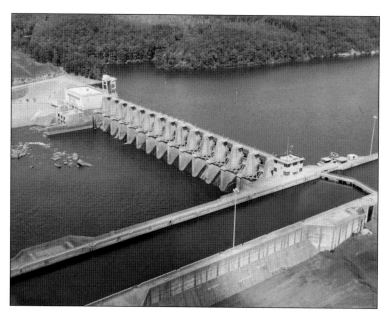

Locks provided an engineering solution to the restrictions that nature put on barge and steamship mobility; for example, by the late 19th century, it was possible for vessels to travel past the Black Warrior falls to its iron and coal operations. The Holt Lock and Dam replaced a series of locks and dams built in the southern bank in the early 1900s.

This view of Jim Walter Resources, Inc., Brookwood No. 5 Mine, 12972 Lock 17 Road, is looking northeast toward the surface plant and conveyors. The Brookwood Mines are the deepest underground coal mines in North America, producing a high-grade medium volatile low sulfur metallurgical coal. The mine employs long wall mining techniques, with belts that convey coal from underground operations to the surface.

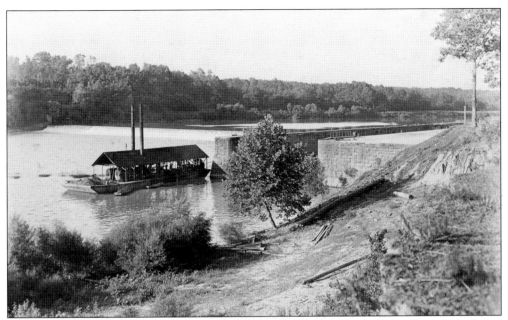

In this c. 1900 image, a barge, with small paddleboats hooked to the shallow side, is docked near lock 17 on the Black Warrior River. Lock 17 was very close to Tuscaloosa and made it possible for excursion boats, ferries, steamboats, and other vessels to proceed along the river.

Central Iron Foundry, also known as Tuscaloosa Steel Company, was once the largest soil pipe plant in the United States. It was also the first fully integrated pipe-making operation in the country, with a coke plant, blast furnaces, and a foundry all located on the site. The facility was shut down around 1970.

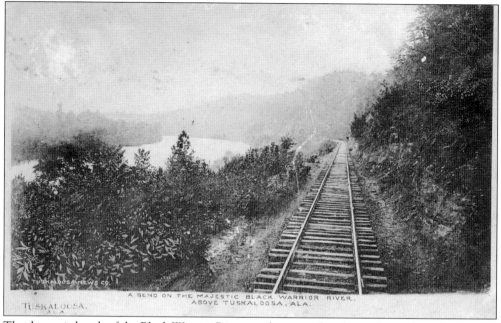

A BEND ON THE MAJESTIC BLACK WARRIOR RIVER,
ABOVE TUSKALOOSA, ALA.

TUSKALOOSA, ALA.

The dramatic bends of the Black Warrior River are shown in this elevated view from the railroad tracks around 1900. This photograph also demonstrates the overlapping functions of the river and the railroad lines before the rails began to play the greater role in opening up mining areas, moving raw materials to processing plants, and transporting finished goods to market.

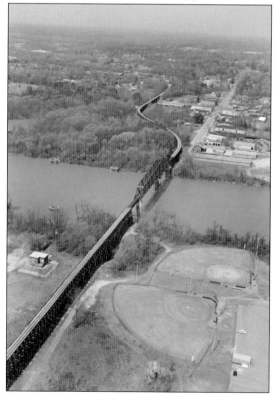

The Gulf, Mobile & Ohio Railroad bridge—a curved wooden trestle with a steel center—spans the Black Warrior River between Tuscaloosa and the commercial area of Northport's historic district. After crossing on a series of concrete reinforced sandstone piers, the trestle bridge passes through a city park and the western side of Capitol Park on its way to the GM&O shop and yard.

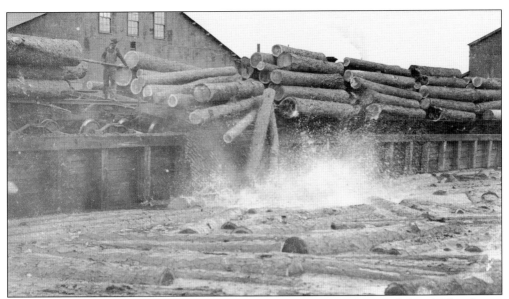

The Kaul family, from Philadelphia, owned Kaul Lumber Company (pictured above). They began acquiring Alabama timberland and milling operations in 1889, and by 1911, owned over 80,000 acres near Tuscaloosa. They constructed a manufacturing complex and company town named Kaulton, producing lumber there until 1931. Referred to as the "Great Yellow Pine Lumber Mills of Alabama," Kaulton produced 50,000,000 feet of lumber annually, specializing in rift sawed yellow pine flooring.

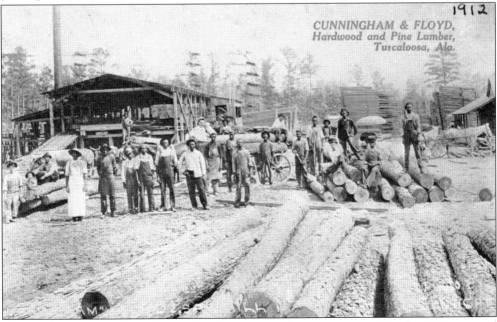

African American workers, along with a few white male workers, paused for this 1912 postcard photograph taken at Cunningham & Floyd Hardwood and Pine Lumber Company. Used for advertising and quick communication, the postcard reflects the industry's association with Tuscaloosa at the time. Originating around 1880, one of Cunningham & Floyd's local competitors was Scott Lumber Company, owned by William D. Harrigan and Frederick Herrick.

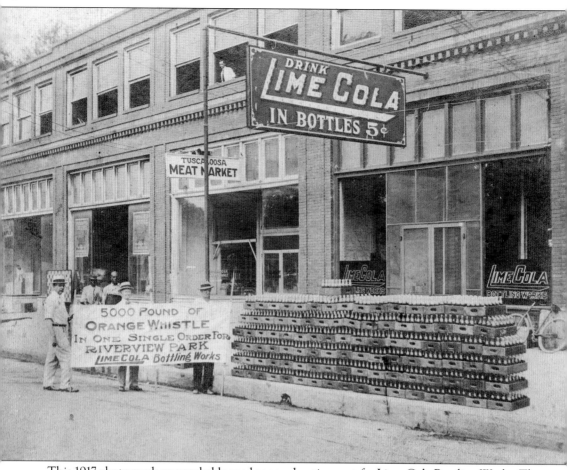

This 1917 photograph was probably used as an advertisement for Lime Cola Bottling Works. The Tuscaloosa-based soft drink company enjoyed impressive area sales of its product for decades. Strategically located next to a meat market downtown, the company used the space as both a drop-in store and as a warehouse where large commercial orders were prepared. It was set up so that buyers could easily drive by and pick up desired quantities. By 1930, the beverage was sold in distinctive nine-ounce see-through green glass bottles embossed with Art Deco designs. The company created a new design every few years, occasionally producing special bottles in limited numbers. The soda bottles became collectibles and remained popular long after the drink was no longer made. The unique containers, especially the Lime Cola "44" bottles, are still in particular demand among collectors.

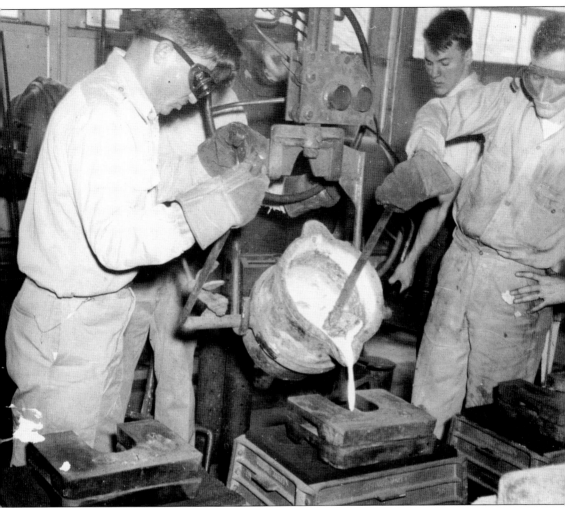

Tuscaloosa shared in the regional growth that occurred after World War II. Work in fields such as construction, transportation, factories, and service—combined with jobs at lumberyards, rubber plants, and metal industries—were driven by increased needs for housing, business expansion and development, and automobiles. A different source of housing needs arose when many veterans took advantage of the G.I. Bill to attend the University of Alabama. The cumulative demands on the city translated into many work opportunities, including those undertaken by these workers pouring hot molten steel in the late 1940s.

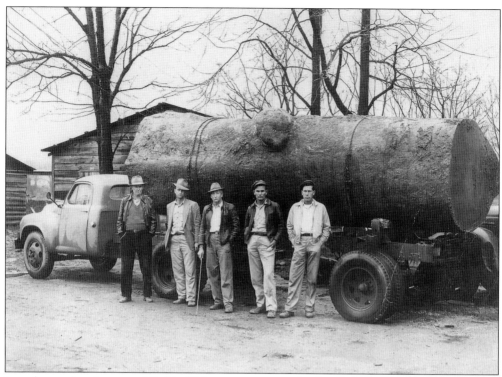

It took over four hours to fell this 65-foot sycamore, and a day to skid the log 350 feet, on Dr. J.E. Shirley's Tuscaloosa County land. The log sold to Stremming Veneer Company for $404.32. Five of the workers pose with the log, which measured 72 inches in diameter at its widest end. The men are, from left to right, J.D. King, John Smelley, Trimm Hamner, John Stillwell, and B.F. Shirley. (Courtesy of Karl Elebash.)

Workers at a lumberyard endure cold, wet weather while engaging in salvage and cleanup efforts after a destructive storm ripped through downtown Northport in 1923. Once the heavy rains subsided, the temperature—which had been unseasonably high—dropped to below normal in the aftermath of the storm.

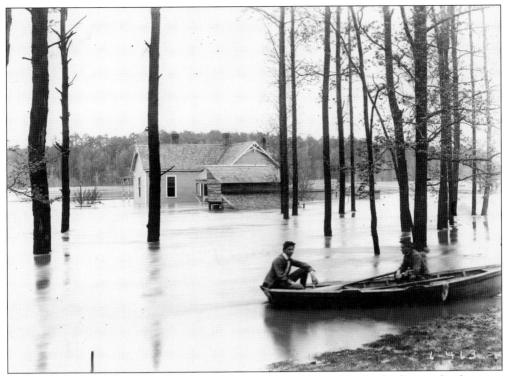

Two men pose in a boat in a flooded area after a severe storm. In the background, a house is half-submerged under water. The clusters of nearby trees show evidence of having been stripped by damaging winds. This is an uncannily serene, pretty picture created because of a destructive weather situation.

A damaging storm that tore through town in the 1950s caused many to recall the deadly tornadoes of March 21 and 22, 1932, which took the lives of 268 Alabamans. They also remembered how the people of Alabama in general—and Tuscaloosa in particular—came to the aid of neighbors immediately after the rains subsided and began to take steps toward rebuilding.

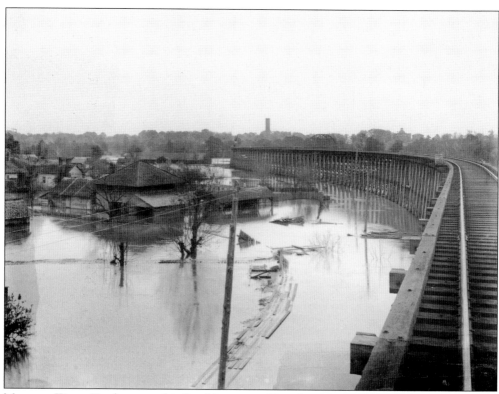

Memnon Tierce II, who traces his family's roots in Tuscaloosa to 1816, recalls life in the 1940s: "Downtown Northport was in the flood zone of the Black Warrior River. This included our house and it would have flooded every spring if it were not on a hill. The low-lying houses and streets flooded about every year. Just up river was Spencer's Mill, and when the creek was at flood stage, the whole area was a huge lake. It was impossible to cross the river to Tuscaloosa by road and old downtown Northport was flooded out. The railroad crossed the river over a high bridge, and the company would let one get on the train at the station, near Holman's Lumber Company, and ride to Tuscaloosa."

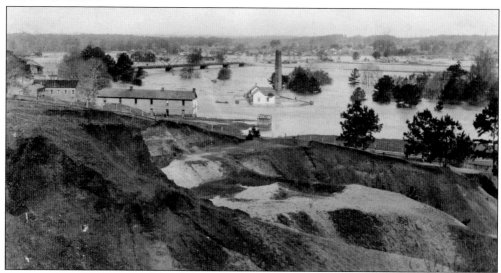

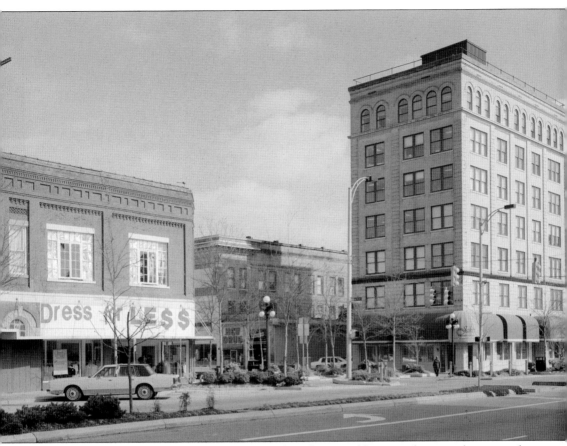

This view of Tuscaloosa, looking southeast with the Alston Building at right, was taken around 1960. The classic building is more than a longtime anchor of the downtown cityscape—it stands as a reminder of the joyous occasions that brought residents and visitors together, with some activities occurring along the avenue across from its front doors and others occurring on its famous roof that flashed a welcoming "Try Tuscaloosa" sign. Many memorable dance parties occurred in its signature roof garden. While the building's space was mainly leased to attorneys, H&W Drugs rented on the first floor for over 50 years. Also, former governors George and Lurleen Burns Wallace were married in the justice of the peace office in this building.

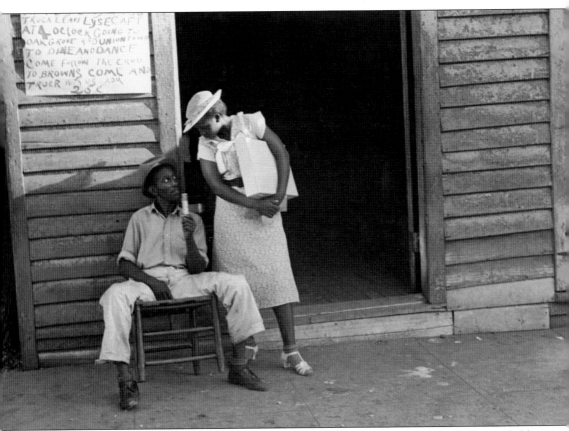

This scene of a couple on a sidewalk, photographed by Walker Evans in 1936, shows a remarkable moment of interaction between the man and woman as they make communicative eye contact while neither appears to be talking. The photographer felt they were waiting for a ride. The freshness of their clothing and the package under the arm of the woman creates a leisurely appearance, but the photograph was taken in the late afternoon on a summer workday; thus, the box probably contains work clothes that she changed out of before heading home. The sign above their heads advertises a day trip and reads: "Truck Excursion; Thurs, July 2, 1936; Truck Leave Lyse Café at 4 o'clock going to Oak Grove and Uniontown To Dine and Dance; Come Follow the Crowd To Brown's; come and Truck with us; Adm 25 cent."

Seven

CIVIL RIGHTS

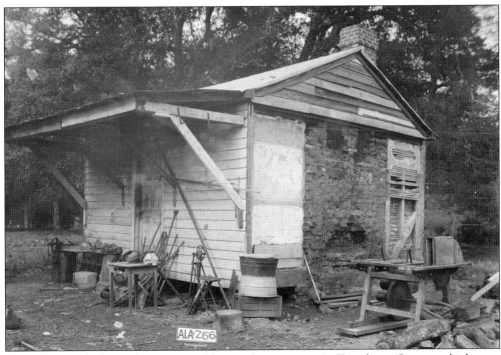

This photograph shows the remains of former slave quarters in Tuscaloosa County, which were used by the owner as a tool shed after emancipation. While it does not carry any immediate signs associated with the institution of slavery, there is a strong narrative in its being labeled "old slave quarters" rather than in terms of its later use. This, in turn, is a reminder that the abolitionist movement was the first organized civil rights movement for African Americans. (Courtesy of the Library of Congress, Prints and Photographs Division.)

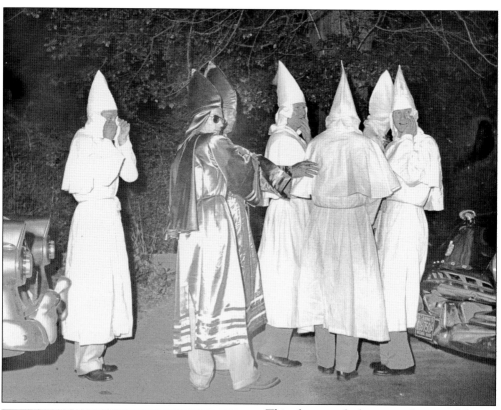

This photograph shows a gathering of the Ku Klux Klan (KKK) in Tuscaloosa on May 14, 1957. Twenty men formed the Tuscaloosa County KKK in Sipsey Swamp in 1868. Leader Ryland Randolph assumed the title "Grand Giant of the Province of Tuscaloosa County." The *Independent Monitor* (1898) ran a cartoon threatening that the KKK would lynch carpetbaggers in Tuscaloosa. Klan activity rose and ebbed over time; this Tuscaloosa gathering was related to anti-desegregation activities.

In *Fighting the Devil in Dixie: How Civil Rights Activists Took on the Ku Klux Klan in Alabama*, Tuscaloosa native and award-winning journalist Wayne Greenhaw examines how the Klan, empowered by Gov. George Wallace's defiance of civil rights laws, grew more violent until confronted by a courageous, determined coalition of blacks and whites. The book covers a time span ranging from Klan bombings and murders in the 1950s to Wallace's 1980s gubernatorial win with the support of black voters. Wallace had changed his political tone by then to appeal more to members of the black communities

Bessemer native Paul R. Jones was denied entry to UA's law school in 1949 because of his race. Unlike Autherine Lucy, Vivian Malone, and James Hood, who entered the university years later, Jones could not find an attorney at the time—black or white—willing to take his case and challenge the state's policy. (Courtesy of the Paul R. Jones Archives.)

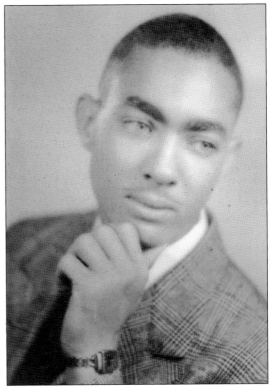

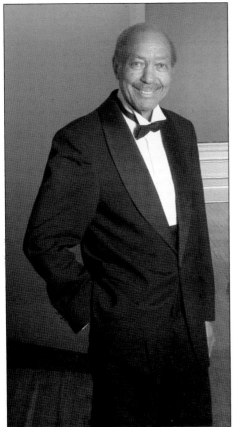

A Howard University graduate, Jones worked for several mayors and for presidents John F. Kennedy and Richard Nixon before excelling in real estate and as a collector of pioneer art. While regional director of ACTION in the 1970s, he approved a major grant to the University of Alabama for adult education. In 2006, he received an honorary law degree from UA. In 2008, Jones donated more than 1,000 works of art to UA as "an indication of his forgiveness of the university." (Courtesy of the Paul R. Jones Archives.)

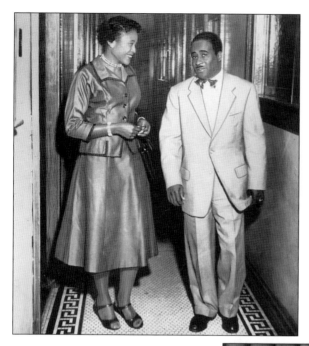

On February 3, 1956, Autherine Lucy enrolled at the University of Alabama as a graduate student in library science. Three days later, a hostile mob formed to impede her admission, but police secured her entry. Outbreaks of student unrest on campus and in the city caused the university to suspend her on grounds that it was unsafe for her to continue attending school. Lucy and her legal team, led by future US Supreme Court justice Thurgood Marshall, filed a lawsuit to overturn the suspension. When the suit was unsuccessful, the university expelled her, charging her with slandering the school. The university overturned her expulsion in 1980, and she earned a master's degree in Elementary Education from UA in 1992.

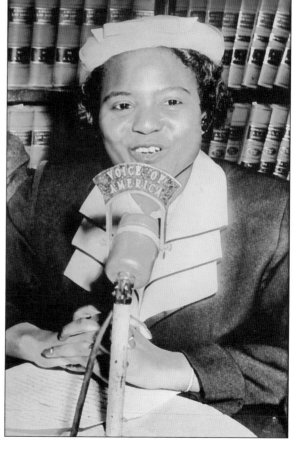

Autherine Lucy contradicted allegations of communist affiliations on a Voice of America radio broadcast on March 7, 1956. She stated: "I categorically deny that I have at any time written a letter to any Communist organization either in America or abroad. Neither have I made a statement for any association, publication, or organization under Communist control. I know very little about Communism and have had no contact with any person or agency known to me to be a representative of the Communist Party. I am an American and I believe in the American system of government. I am also a Christian and believe in the teachings of the Christian religion."

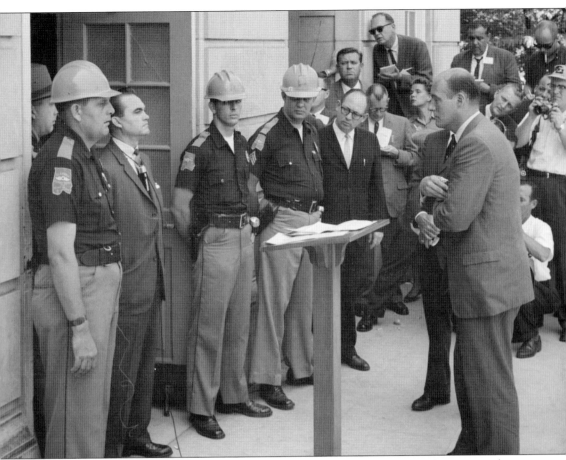

On June 11, 1963, Deputy Attorney General Nicholas Katzenback escorted Vivian Malone and James Hood to the University of Alabama to register for classes. Despite the government's desegregation mandate and Pres. John F. Kennedy's instruction that the governor "fall back on his planned standoff," Gov. George Wallace stood in front of the auditorium doors and physically denied them entry, stating they could not attend the facility because they were black. When he took office, Wallace had proclaimed: "Segregation today, segregation tomorrow, segregation forever." He also based his refusal to admit them on "state's rights." Katzenback and the two students temporarily withdrew. The president federalized the Alabama National Guard and put them on standby. Brig. Gen. Henry Graham and other guards returned to Foster Auditorium, where Wallace blocked the doorway again. Graham saluted Wallace, and then said: "It is my sad duty to ask you to step aside by orders from the President of the United States." Wallace finally stepped aside and allowed Malone and Hood to enter. The incident made international headlines and became known as "Governor George Wallace's Stand in the Schoolhouse Door." (Courtesy of the *Birmingham News*.)

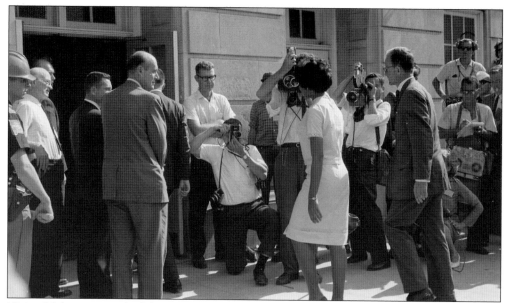

Vivian Malone approached the entrance of Foster Auditorium escorted by troops on the blistering hot day of June 11, 1963, to enroll in classes at the university. Her entrance to the university, along with that of James Hood, occurred as the civil rights struggle raged across the South. The next day, African American student David McGlathery registered without incident at the university's extension center in Huntsville. (Courtesy of the *Birmingham News*.)

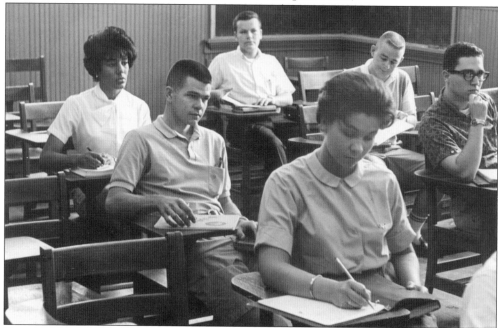

Vivian Malone (left), shown during her first day in class, attended without the violence that occurred when Autherine Lucy enrolled at the university in 1956. Despite their ideological differences, the university, federal, state, and local authorities agreed that law and order must be maintained. On May 30, 1965, Malone became the first African American to graduate from the University of Alabama in its 134 years of existence.

Acclaimed literary and cultural critic Dr. Trudier Harris grew up in Tuscaloosa, attending Stillman College before receiving masters and doctorate degrees from Ohio State University. She has written and edited more than 20 works, and taught at the University of North Carolina at Chapel Hill for 30 years, where she was the J. Carlyle Sitterson Professor of English. Harris retired to her native Tuscaloosa, serving as a visiting scholar-in-residence in the University of Alabama English Department.

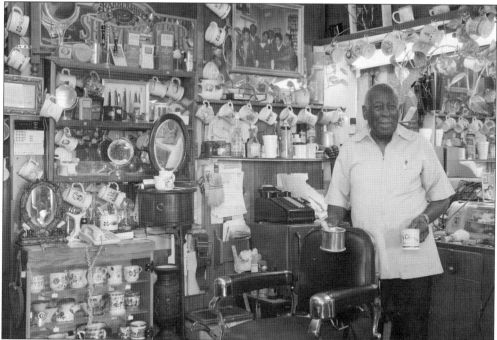

On June 9, 1964, Rev. Thomas Linton witnessed racial turbulence in Tuscaloosa just steps from his barbershop when police interrupted protesters planning a peaceful demonstration at the First African Baptist Church with tear gas and nightsticks. Since that time, Linton's downtown shop on T.Y. Rogers Avenue has been a living museum that tells the story of the city from his perspective as a barber, civil rights activist, and minister.

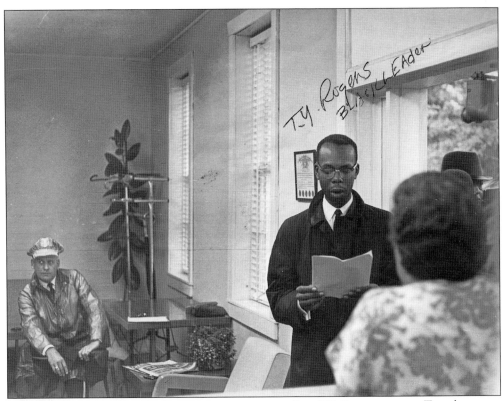

T.Y. Rogers BLACK LEADER

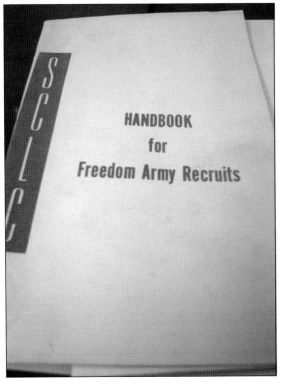

HANDBOOK
for
Freedom Army Recruits

Rev. T.Y. Rogers came to Tuscaloosa in 1964 to serve as the pastor at First African Baptist Church on the recommendation of Rev. Martin Luther King Jr. He is most remembered for leading an organization of black citizens, the Tuscaloosa Citizens for Action Committee (formed in 1964), in challenging racially discriminatory practices. The group was formed when the new Tuscaloosa County Courthouse put up "whites only" signs in front of the bathrooms.

The *Handbook for Freedom Army Recruits*, by Martin Luther King Jr., was given to Rev. T.Y. Rogers when King personally sent him to Tuscaloosa. The pamphlet, written in early 1964, outlines what to do and not do in case of being incarcerated and includes nonviolent strategies for surviving jail time and attracting attention to a cause.

Fifty years after Paul R. Jones was denied entry into the University of Alabama School of Law, Bryan K. Fair was hired to teach law. An expert in issues relating to race, gender, civil rights, and the Constitution, Fair was named the Thomas E. Skinner Professor of Law in 2000. He served as director of diversity and international programs in 2007 and associate dean for special programs in 2008. He directs the University of Fribourg/UA cooperative educational program and is a summer academic support administrator and teacher. Twice named a law school dean's scholar, he frequently comments in local, national, and international press on constitutional issues pending before the Supreme Court. He served as an assistant vice president for academic affairs from 1994 to 1997, is an 11-time member of the law school commencement hooding team, and was twice named the law school's outstanding faculty member by students.

On November 3, 2010, the University of Alabama paid tribute to the three African American students whose enrollment represented UA's first steps toward desegregation in the 1950s and 1960s—Autherine Lucy Foster, James Hood, and the late Vivian Malone Jones—at the dedication of the Malone-Hood Plaza and Autherine Lucy Clock Tower outside of Foster Auditorium.

Discover Thousands of Local History Books
Featuring Millions of Vintage Images

Arcadia Publishing, the leading local history publisher in the United States, is committed to making history accessible and meaningful through publishing books that celebrate and preserve the heritage of America's people and places.

Find more books like this at
www.arcadiapublishing.com

Search for your hometown history, your old stomping grounds, and even your favorite sports team.